BETWEEN THE UTOPIAS

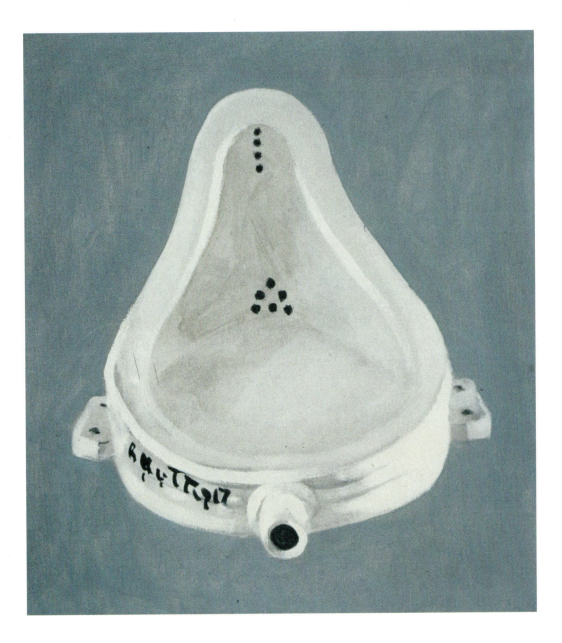

BETWEEN THE UTOPIAS

New Russian Art during and after Perestroika (1985-1993)

Andrei Kovalev

CRAFTSMAN HOUSE
G+B ARTS INTERNATIONAL

Craftsman House wishes to acknowledge the assistance and co-operation
of Ludmila Makarova and her associates at Avtor Publishers, Moscow,
in the production of this book. The text and illustrations were compiled
by the staff of Avtor Publishers in conjunction with the author.

Distributed in Australia by Craftsman House,
20 Barcoo Street, Roseville East, NSW 2069
in association with G+B Arts International:
Australia, Austria, Belgium, China, France, Germany,
Hong Kong, India, Japan, Luxembourg, Malaysia,
Netherlands, Russia, Singapore, Switzerland,
United Kingdom, United States of America

ISBN 976 6410 50 X

Design *Craftsman House*
Cover Design *Caroline de Fries and Nichola Dyson Walker*
Printer *Kyodo Printing Co., Singapore*

1. (Frontispiece) Avdei Ter-Oganyan, *Marcel Duchamp. 'Fountain'*, 1992,
Oil on canvas, 100 x 90 cm, Contemporary art collection, Tsaritsyno Museum, Moscow,
Photograph: Easy Life agency

C O N T E N T S

T he declaration of the policy of perestroika in 1985 and the events that were to follow created conditions that were favourable for cardinal changes to take place in Russian art. The situation in the world of art has altered speedily in less than ten years. The geopolitical shifts caused transformations even in the critical terminology used: 'Soviet non-official art' turned into mere 'Russian art'. The imposed political dimension was thus replaced by a purely geographical one. However, 'the second Russian cultural revolution' that took place parallel with the liberalisation in politics and the economy resulted only in the reinstatement of the habitual structure of those institutions necessary for the normal functioning of art. The image of the artistic scene is still in the process of transformation, and most of the key functional institutions of contemporary art — museums, institutes of contemporary art and art journals — have not taken final shape; they still exist only in the form of announced and partially realised projects.[1] For instance,

2. Oleg Kulik, *Gorby*, 1992, Armoured glass, 320 x 160 x 120 cm, Collection: European Merchant Bank, Moscow, Photograph: Vadim Zemsky

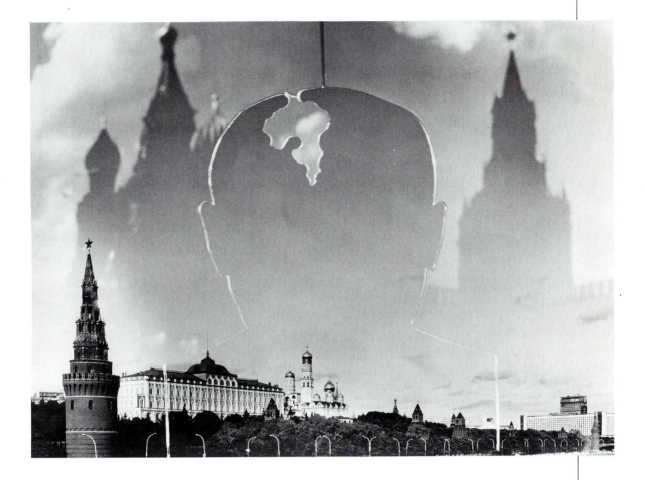

the Museum of Contemporary Art has the most representative collection, and exhibitions drawn from the collection are held regularly, but the museum itself does not have either its own premises or a clearly defined programme of actions.

Idealised projections of human consciousness prevailed over pragmatic experience to such a degree that even the art market was being built as an ideal project. As a case in point, the most successful structure of the art market — the Moscow International Art Fair — has the abbreviation ART-MIF (the Russian phonetic equivalent of 'myth').[2] When the first fair was arranged in 1990, a home art market was non-existent. That is why the allusion to mystification which has been preserved to this day in the name of the fair is not surprising: first an event is given a name to mark its territory, and it is then filled with functional and productive mechanisms. Such a sequence of actions is characteristic of Russian culture, where a word traditionally models and changes reality.

3. Konstantin Zvezdochetov, *Procession*, from the 'Perdo' series, 1987, Orgalite, alkyd enamel, 100 x 150 cm, Private collection, Germany

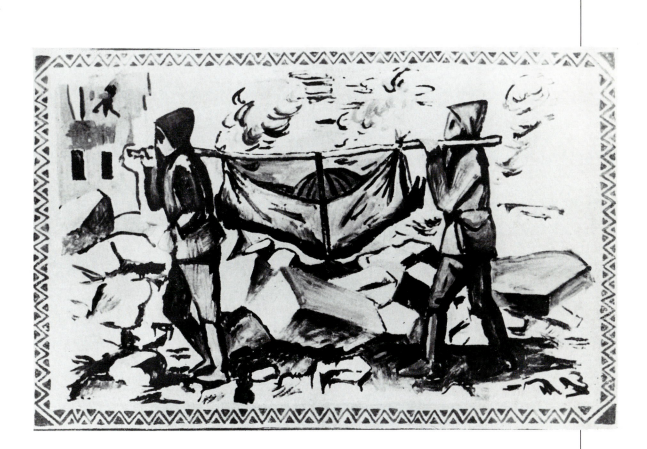

4. Yuri Leiderman, *The Well and the Pendulum*, 1992, Installation, Wood, paper, metal, plaster figurines, 'Animalistic Projects' festival, Regina Gallery, Moscow

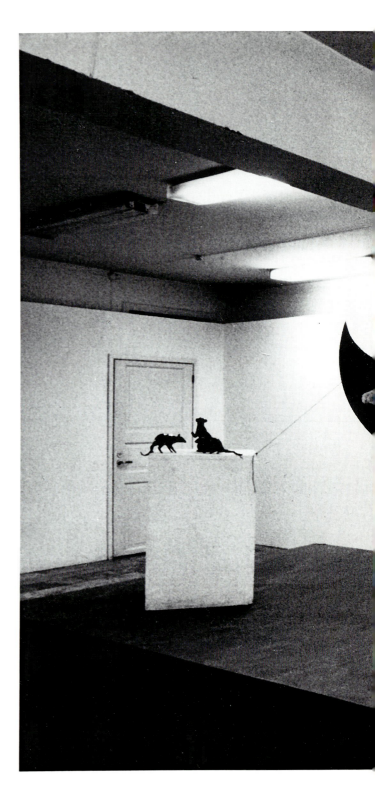

5. Sergei Shootov, *Sensuous Experiments*, 1993, Video-installation. Detail, Courtesy: Shkola Gallery, Moscow

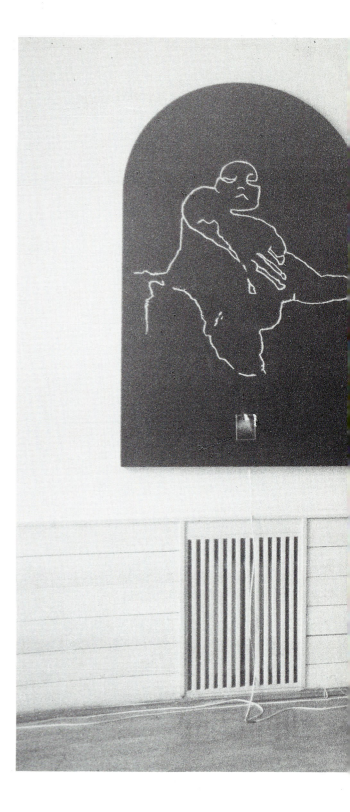

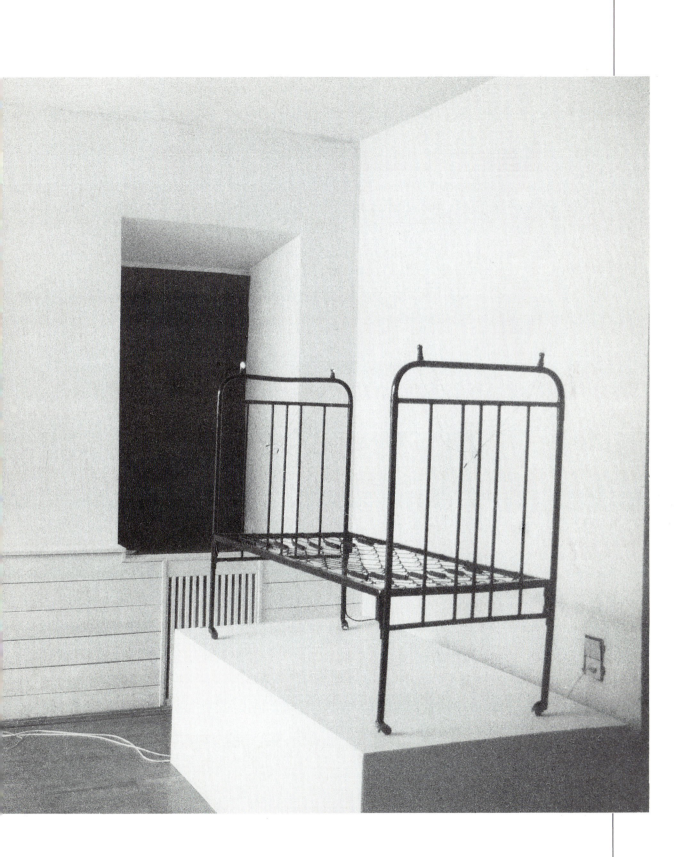

6. Aidan (Aidan Salakhova),
Golden Legend, 1991,
Installation in the 1st Gallery.
Detail, Oil on canvas, papier-
maché fruit, Courtesy: Aidan
Gallery, Moscow

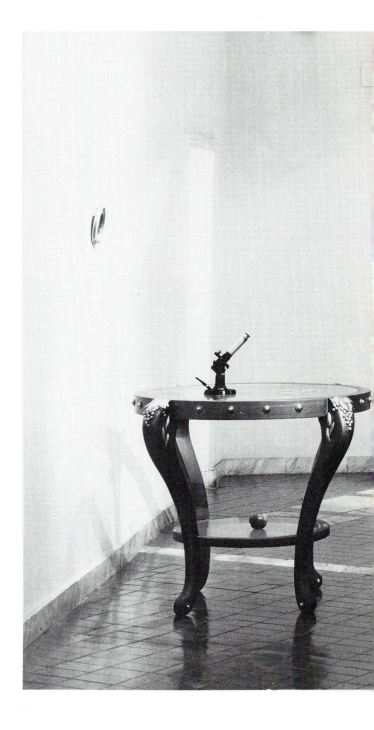

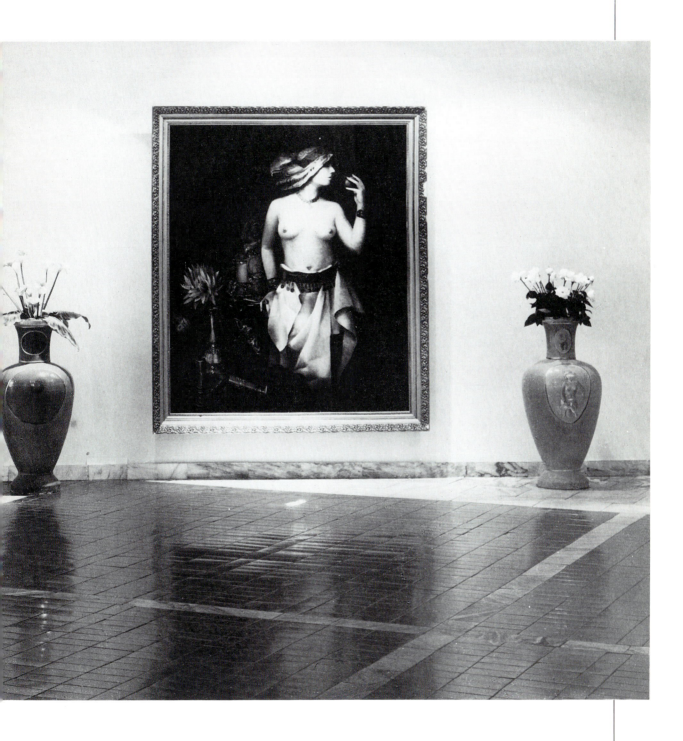

A system of art galleries that reflected practically the whole spectrum of existing individual strategies was to prove to be the better formed and more complete structure of the new architecture of the artistic scene. It is a complete puzzle how private initiatives have managed to survive and take root in the permanent economic chaos and primordial state of the market. Whatever the case may be, exhibitions are opened regularly and catalogues are published. Open, normal life with the measured dynamics of private viewings and press reviews proceeds in Russia against the background of political and economic madness.

It is not that the new state of affairs has been achieved and assimilated all at once. The unceasing efforts of enthusiasts has helped overcome the resistance inherent in the old ossified system. Ordinary things like the arrangement of an exhibition, participation in an international exposition, or the opening of a small art gallery were all great conquests.

7. Dmitry and Inna Topolsky,
The Artist and the Model, 1993,
Photograph, 75 x 60 cm, Courtesy:
Yakut Gallery, Moscow

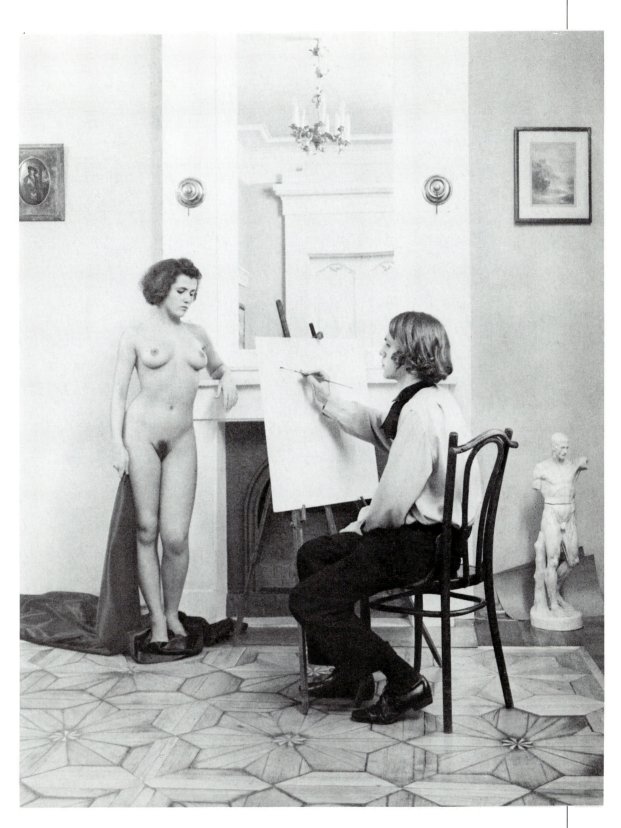

The process of legalisation and socialisation of all that was non-official was appreciated like an ongoing holiday and was seen as the triumph of free creativity, now liberated from the oppression of totalitarianism. The euphoria that overwhelmed Underground artists, their critics and admirers was also nourished by the singular international success of non-official art in the first years of perestroika. Viewed from this side of the iron curtain, the West appeared as an oasis of contemporary art, where a local avant-gardist persecuted by the authorities would be understood at last, or would at least be appreciated.

The general interest of the West in perestroika and glasnost showed itself most actively in the sphere of art. The results of this interest were beyond even the most fantastic expectations of Russian artists. They were given an opportunity to display their works at various exhibitions, and to sell their pictures to museums and private collectors; and professional journals and popular newspapers wrote about them. This new intensity of

8. Gor Chokhal, *Sentimental Travel*, 1990, Installation in the 1st Gallery. Detail, Courtesy: Aidan Gallery, Moscow

life brought new evidence of the artist's social importance. One circumstance should be taken into consideration, however. Although non-official art was now 'permitted' at home, society seemed to lose its former curiosity, which, in many respects, had been provoked by the taboos. This explains why all art was primarily orientated toward the West.

The excitement surrounding Russian art, 'the Russian boom', reached its peak at the Sotheby's auction in Moscow in the summer of 1988. The high — even against world standards — prices for works of alternative art offered side by side with classical avant-garde work were seen as a kind of historical compensation for the many years of underground existence.

9. Vladislav Mamyshev, *Unhappy Love*, 1993, Painted photograph, 60 x 70 cm, State Russian Museum, St Petersburg, Photograph: Hans Yörgen Buckard

The unheard-of success created an illusion of infinite possibilities; however, Western realities turned out to be much tougher than the ideal conceptions that had been formed in conditions of isolation. It gradually transpired that the artists — who had developed adequate mechanisms to resist the totalitarian ideology that they were used to — were absolutely helpless before the total pressure of the market, with which they were unfamiliar.[3] The art market, being motivated by political considerations, made stringent demands for 'the art of perestroika' that was lavishly encrusted with ironic Soviet symbols, or at least had some easily recognisable regional features. The expectations created by the political situation and the market gave rise to a whole industry of hack-work. Under the pressure of constantly mutating political dominants, even Sots-Art, this important trend in Russian art, was somehow swallowed up in the epidemic. Under such conditions, a more complex and responsible self-identification in the art universe itself was needed.

10. Arsen Savadov and Yuri Senchenko, Untitled, 1992, Oil on canvas, plastic, 350 x 400 cm, Oklahoma City Museum, USA, Courtesy: M. Guelman Gallery, Moscow

The success of the Sotheby's auction produced a significant influence both on external markets and the situation at home. Economic considerations prevailed over ideology, and the State, receiving a telling gain from the auction, finally stopped persecuting independent art. Thus, art was left to itself. The first attempts to legitimise and consolidate non-official art were made from late 1986 through to 1988, in an exhibition hall on the outskirts of Moscow near Kashirskaya Metro station. The atmosphere at the exhibitions was highly enthusiastic; they were accompanied by heated disputes, concerts, performances,

11. Oleg Tistol and Konstantin Reunov, *An Act of Artistic Opposition*, 1990, 'The Late-Century Art' Programme, The Artist's Central House, Moscow

theatricals and recitations that demonstrated the unity of the whole of non-official art. The exhibitions themselves were quite a strange mixture of different trends whose representatives gathered together because they had a common experience of dissidence. It gradually became obvious, though, that the formerly rejected trends that had now surfaced were in real aesthetic conflict with each other. Nonetheless, efforts were at first made to maintain the unity of the oppositional movement; but very soon the paths of the oppositionists would diverge — some would join the elite of the home and international art, others would focus on the abilities they found they possessed as commercial artists, still others would withdraw altogether.

12. Yuri Khorovsky, *Voting on the Question of Socrates: Death Penalty, 399 BC*, 1993, Installation. Detail, 10 x 1 x 1 m, Author's property, Courtesy: M. Guelman Gallery Moscow

13. Avdei Ter-Oganyan and Alexander Sigutin, *The Futurists Going to the Kuznetsky: In Commemoration of Kazimir Malevich and Aleksei Morgunov's First Public Performance*, 1992, Moscow, Photograph: Igor Mukhin

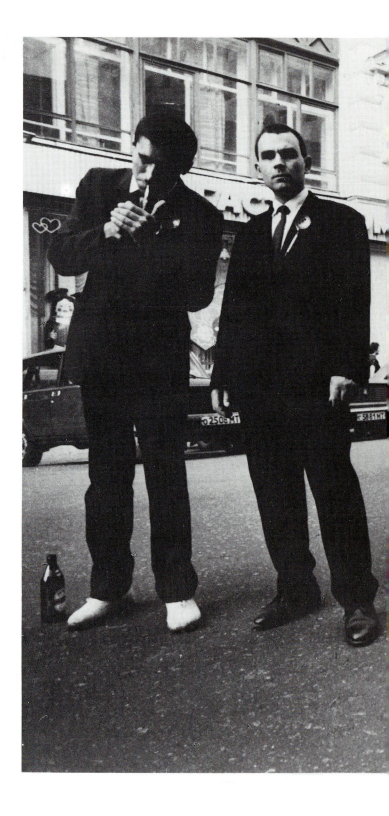

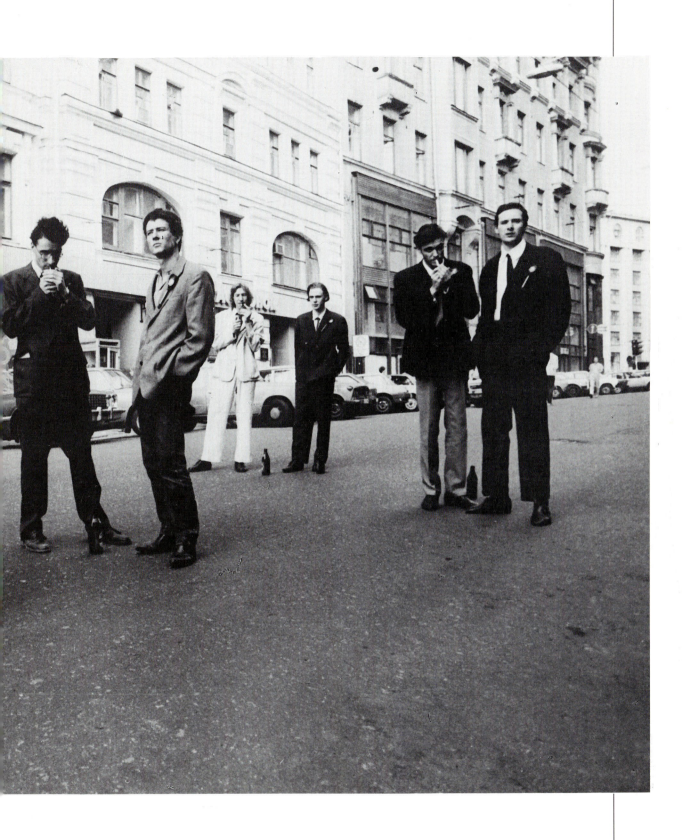

Several thematic displays were arranged in the Kashirskaya hall, and these gave concrete form to the topics of the theoretical debates held by Moscow intellectuals at unofficial seminars during the 1970s, such as the links between the early avant-garde and various trends of independent art, or the place of folk art and primitivism in contemporary artistic culture. The expositions based on these theoretical foundations ('Folk Traditions in Contemporary Culture' and 'Geometry in Art', both in 1987) marked the early stage of the process of restoration of the history of Russian art.

During its underground period, although independent art developed a masterfully thought-out ideology, axiology and methodology, its own history, for one reason or another, still remained an undivided pre-scientific myth. Single attempts at historical surveys were made, of course; for instance, the unpublished text by Ilya Kabakov 'The '70s' (1983). These surveys were mostly autobiographical, but they nevertheless greatly influenced the ensuing process of historisation. The absence of a coherent

14. Alexander Sigutin, *Fresh Paint*, 1993, Art exhibition in Tryokhprudny Lane, Photograph: Igor Mukhin

15. Oleg Kulik, *Art at First Hand or the Apologia of Diffidence*, from Vladimir Ovcharenko's collection, 1992, Exposition project, Regina Gallery, Moscow, Photograph: Pavel Kiselyov

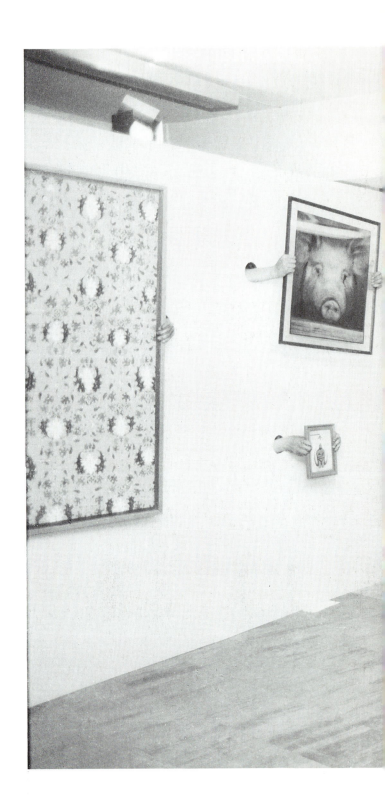

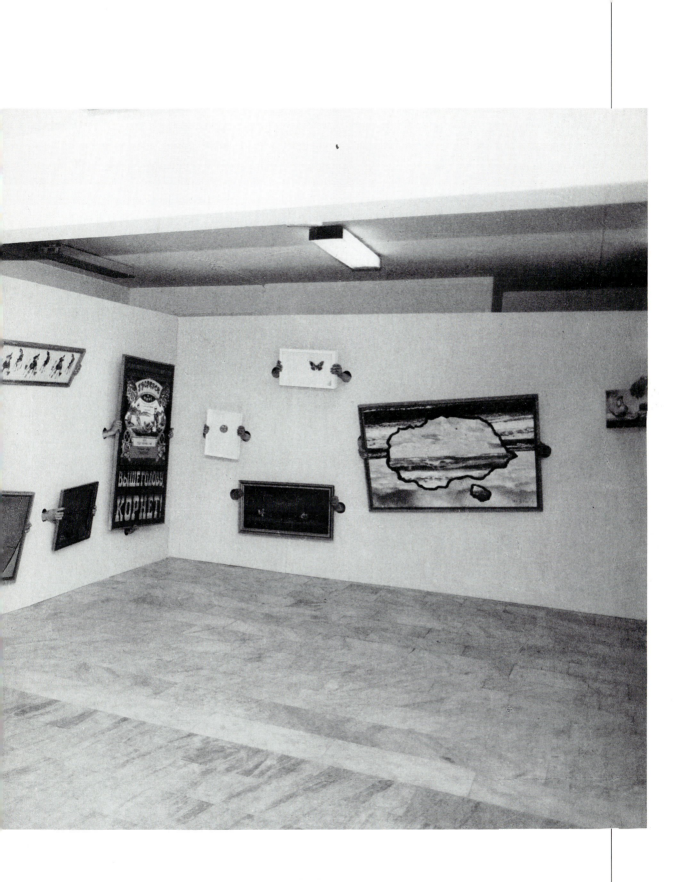

conceptualisation of the history of contemporary art was a serious obstacle for further advance.[4] The first important step towards restoring the temporal links was a series of conceptually developed displays under the general name 'The Retrospective: 1957–1987' (1987) arranged by the Hermitage society. A group of young art historians and artists led by Leonid Bazhanov had made an attempt to reconstruct the history of contemporary Russian art beginning from the 1960s. Later on, Andrei Yerofeev, one of 'The Retrospective' curators, started a museum of contemporary art, which is now known as the collection of contemporary art in the Tsaritsyno Museum. The display 'Toward the Object' (1990) in the new museum was of fundamental importance, for it specified the range of phenomena determined to be 'contemporary art'. Painting as such was practically excluded from its coverage, no matter what great traditions it upheld and continued, and the circle of authors and ideas was actually reduced to Moscow Conceptualism.

16. Anatoly Osmolovsky, *Leopards Bursting into the Temple*, 1992, Installation. Detail, 'Animalistic Projects' festival, Regina Gallery, Moscow

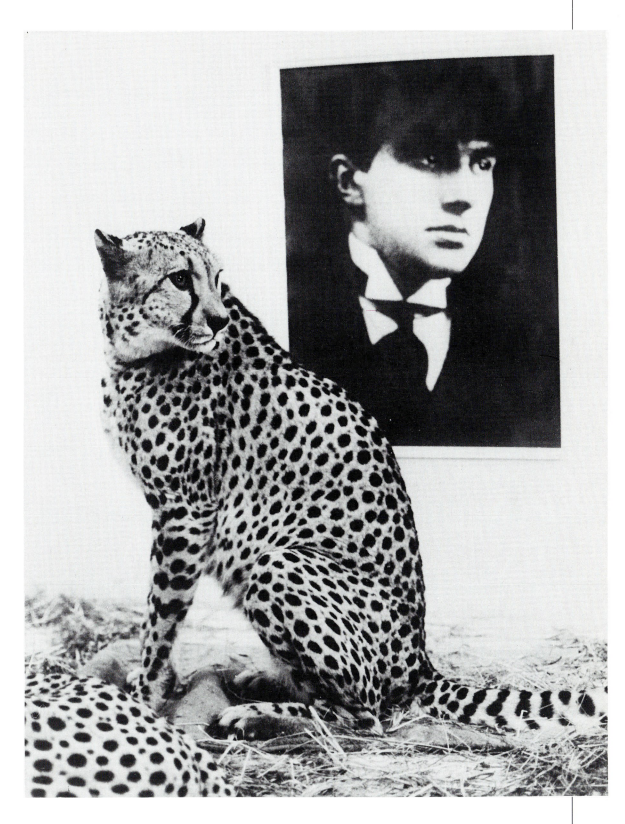

This trend of Russian art was treated as something all-embracing, so broadly that for some period of time it was synonymous with 'contemporary art'. Its vital diversity was the reason for such a generalisation. Because of its flair for virtuosic work with elusive meanings, Moscow Conceptualism had managed to absorb and process a multitude of practices, from Pop-Art to Simulationism. As an art movement, it was distinguished by a carefully thought-out group ideology and the ability to concentrate on collective work. This is precisely why it proved so successful and productive on the Moscow artistic scene in the second half of the 1980s. The devised practice of intellectual speculation and the parallel referencing of any gesture that was made enabled the habitual understanding of an exposition to expand beyond that of a group of suitable authors and a set of suitable works to encompass an organisationally complex action. The formal institutionalisation of

17. Giya Abramishvili in front of *Reagan* (1987) by the World Champions group in the studio in Furmanny Lane, Moscow, 1988

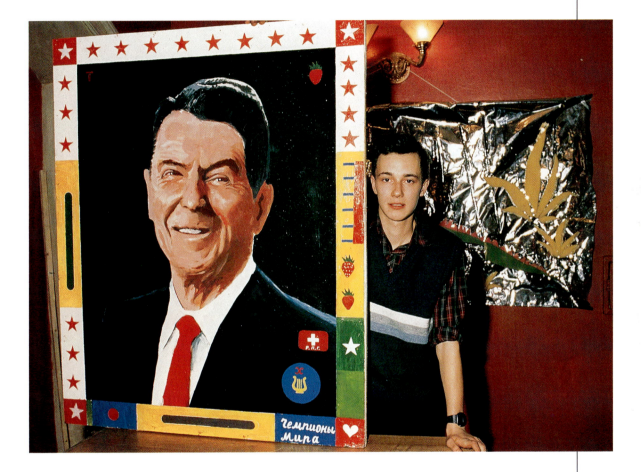

Moscow Conceptualism took place in 1987 in the Avant-Gardists' Club, which united artists of all ages — from Ilya Kabakov to the young group of World Champions. The exhibition 'Dear Art' (1989) in the Youth Palace in Moscow was one of the most prominent actions arranged by the Avant-Gardists' Club. This exhibition referred one simultaneously to the new market situation and the attitude to art as the dearest value cherished by the Underground.

The forceful intellectual and analytical technique elaborated in the 1970s by Ilya Kabakov, Andrei Monastyrsky and Boris Grois greatly attracted the artists of the younger generations. In the early 1980s, Sven Gundlakh, Vladimir and Sergei Mironenko and Konstantin Zvezdochetov joined together to form the Mukhomor group, based on Moscow Conceptualist traditions. Their artistic practices were marked by a violent aggressiveness in the spirit of the New Wave. It appeared, however, that Moscow Conceptualism blocked those forms of radicalism that were considered too open. That is

18. Konstantin Zvezdochetov, *Indices*, 1986, Oil on canvas, 200 x 150 cm, Private collection, Germany

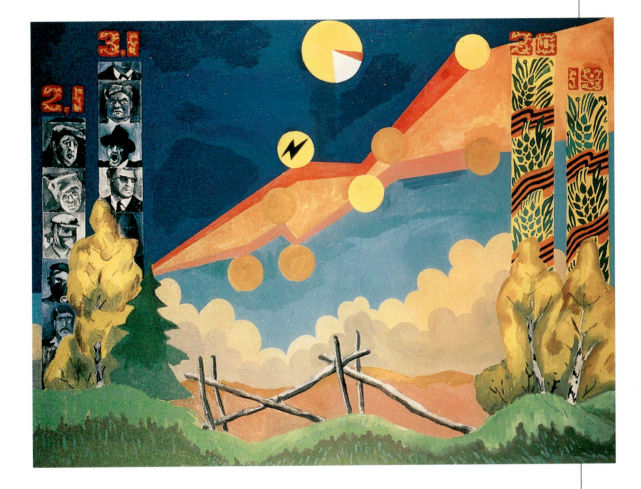

why Konstantin Zvezdochetov, the Mukhomor leader, made one more attempt to initiate a radical counter-movement in 1986. The World Champions, the group he banded together (Giya Abramishvili, Andrei Yakhnin, Boris Matrosov and Konstantin Latyshev), travestied the Modernist idea of the Great Victory.[5] Their most famous action was the exhibition in Sandunovskiye Bathhouse within the framework of 'The Hygiene of Art' project whereby serious works by the members of the Avant-Gardist's Club were displayed in the functioning bathhouse. World Champions, the last barricade of counterculture, to use Zvezdochetov's definition, failed to withstand the temptations of the market; however, the left-radical and anarchist experiments staged by the Mukhomor group and World Champions were a token of the unrealised intentions of a toughly provocative art.

19. Timur Novikov and Inal Savchenkov in front of Inal Savchenkov's painting. Photograph: from the cover of a special 'youth' issue of *Iskusstvo* magazine (No 10, 1988), Moscow

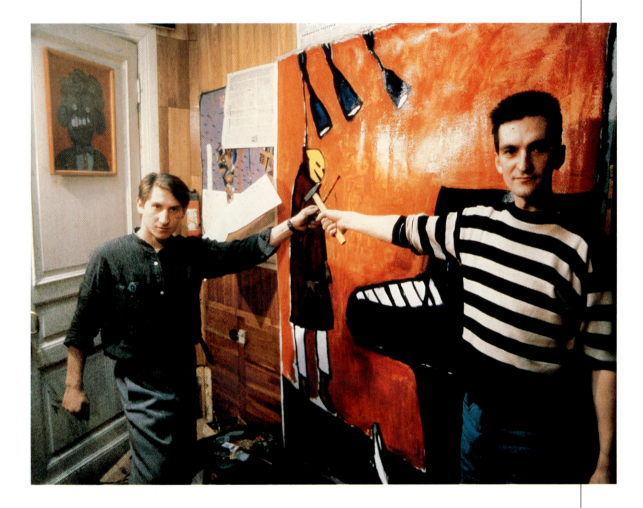

Moscow Conceptualism continued to maintain its high authority and its status as the basic trend during the late 1980s and early 1990s. The 'younger' Conceptualists of the Medical Hermeneutics (Pavel Pepperstein, Sergei Anufriev and Yuri Leiderman) demonstrated superb intellectual artistry in their total codification of Conceptualist discourse, hypertrophying its psychedelic aspects to the utmost. Intellectual pulses from the classical Conceptualism of the 1970s to the post-Conceptualist discourses prevailing at that point passed through the 'bewitching mannerism' (Pepperstein) of Medical Hermeneutics. Yet, in that period it was already difficult for the members of the Moscow *Noma* (the self-appointed name of the community of Moscow Conceptualists) to keep their former

20. Yuri Leiderman, *The Best and Very Dubious*, 1991, Installation. Detail, Oil on canvas, cardboard, paper, crayon, 1.0 Gallery, Moscow, Author's property

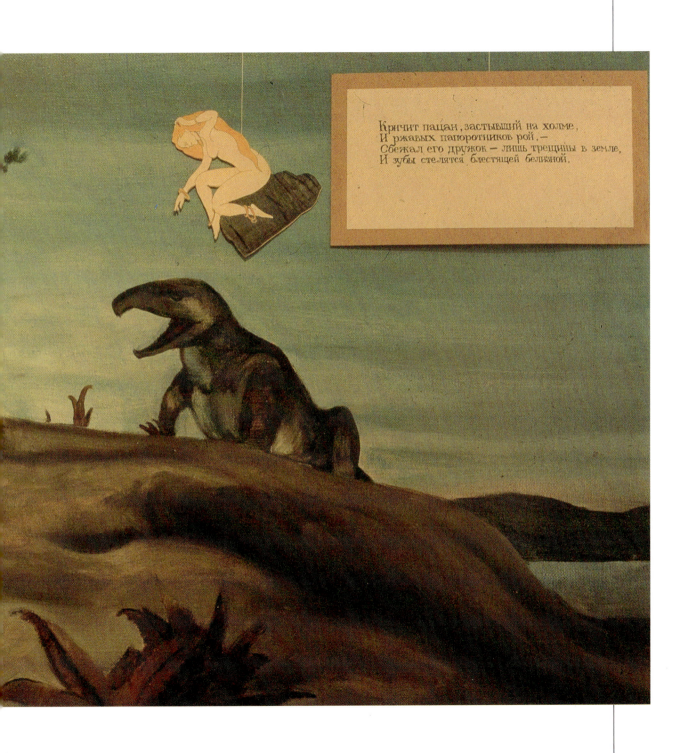

Кричит пацан, застывший на холме,
И ржавых папоротников рой,—
Сбежал его дружок — лишь трещины в земле,
И зубы стелятся блестящей белизной.

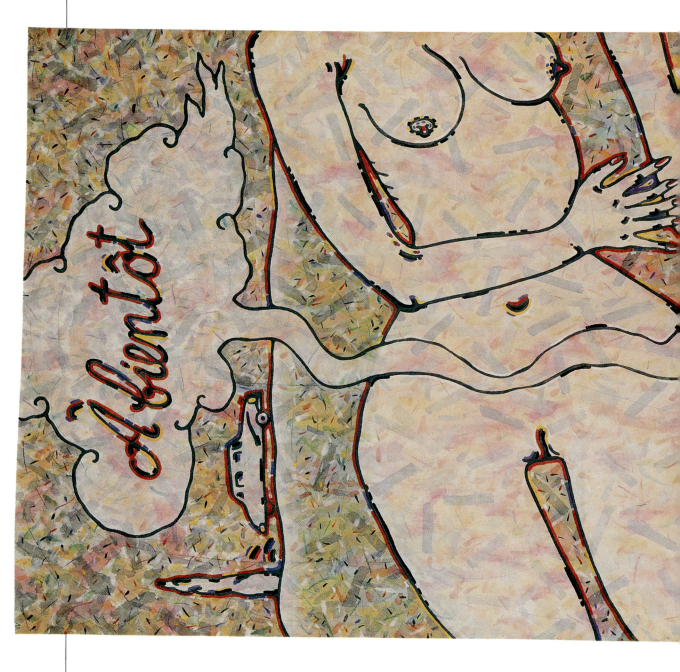

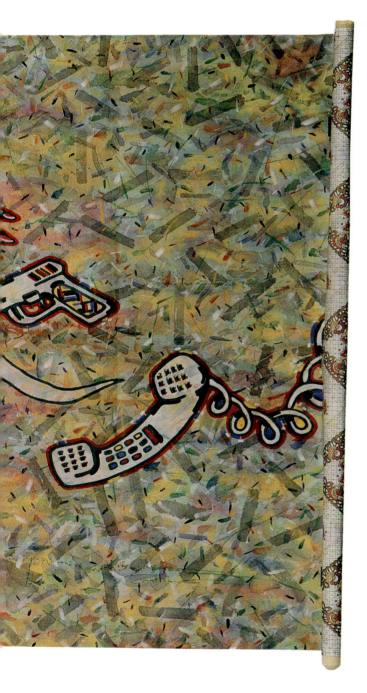

21. Nikita Alekseyev, *The Gun and the Telephone*, 1987, Oil cloth, tempura, 135.5 x 267 cm, Contemporary art collection, Tsaritsyno Museum, Moscow

positions as the local nobility, and they were gradually losing their mystified status as the bearers of 'the high teaching'. Narrowed to one of the trends active on the local stage, Conceptualism is localised nowadays in the L-Gallery, a leading art gallery in Moscow.

The general line of artistic development in the past five years consisted precisely in the search for a route of retreat from the Conceptualist paradigm. Various artists and groups found it either in a form of metaphysics that was more open than that of the Conceptualists, or in a deliberate de-intellectualisation of art, or else in overloading the dry Conceptualist carcass with kitsch beauty. A graphic example of direct apostasy was demonstrated by Yuri Leiderman, a former member of Medical Hermeneutics, who until quite recently was a staunch apologist of 'the canon of emptiness', 'side vision' and similar intellectual speculations that were practised in the circle of the Moscow Conceptualists. Leiderman eliminated the intellectual archness implicitly inherent in

22. Nikolai Kozlov, *Bad Regime*, 1987, Installation, Mixed technique, 284 x 74 x 15 cm, Contemporary art collection, Tsaritsyno Museum, Moscow

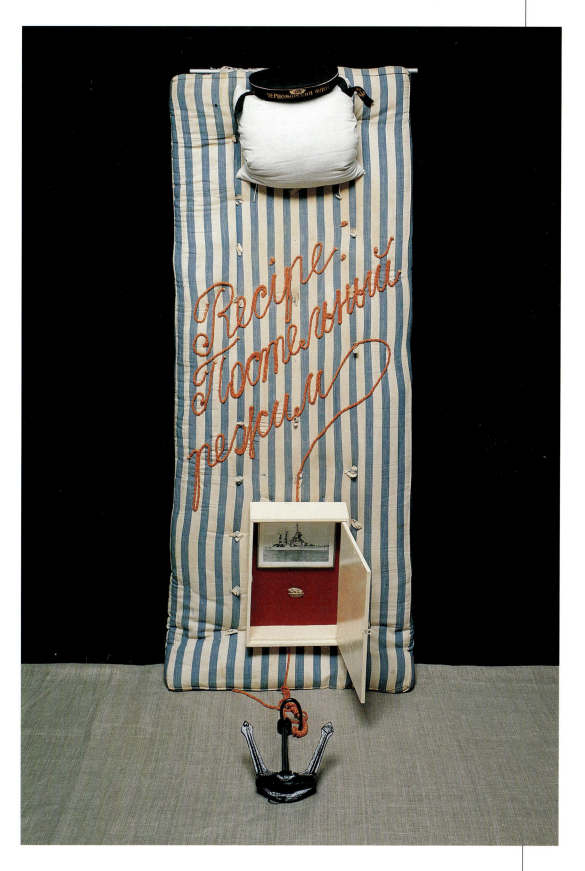

Conceptualism and tried to move to a more tangible art, to an authentic and morally responsible idiom. Anton Olshwang found another way out of Conceptualist dogmatism.[6] His metal constructions had the appearance of archaeological discoveries made in the shrines of unknown Valhalla. This material, however, came from the scrap-heap of post-Gutenberg technogenic civilisation: zinc forms and the scrap from the manufacture of aluminium kitchenware. Although Olshwang's work with the inverted signs of things found in the dump might resemble the practice of the Moscow Conceptualists — who had been preoccupied with emptying things and signs of their meanings — this resemblance was in appearance only. Olshwang, on the contrary, wanted to return the associative richness of meanings to the remnants of the stamped products of industrial manufacture, to cultivate their mythogenic quality.

23. Anton Olshwang, *At a Piece of Work*, 1991, Installation, 'In the Rooms' exhibition, Bratislavia, Aluminium, Contemporary art collection, Tsaritsyno Museum, Moscow

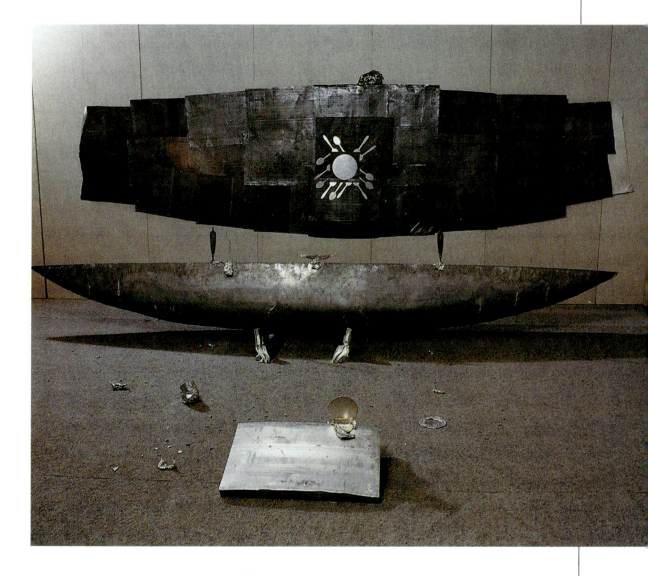

The late 1980s and early 1990s did not produce such generally recognised leaders as Ilya Kabakov and Andrei Monastyrsky were in the 1970s. The discourses began to split schizophrenically, artistic strategies mutated continuously, they emerged and sank. The static hieratic opposition of official and Underground art gave way to the Brownian motion of quickly changing intellectual vogues. Several recently opened Moscow galleries served as the material basis for the multitudinal varieties of Russian topical art; they were the space where continuous intellectual fermentation proceeded. For this reason, the latest period of Russian art can be characterised as the epoch of the art galleries boom. Five of the best Moscow art galleries — l–Gallery, Regina, Shkola, 1.0 and M. Guelman (the last three link into the Contemporary Art Centre, which has its own premises for large thematic projects) — formed a structure flexible enough to respond to the changes of the intellectual climate and also to influence this climate effectively.

24. Georgy Guryanov, *The Pilot*, 1989, Canvas, acrylic, 185 x 110 cm, Paul Judelson Arts, New York

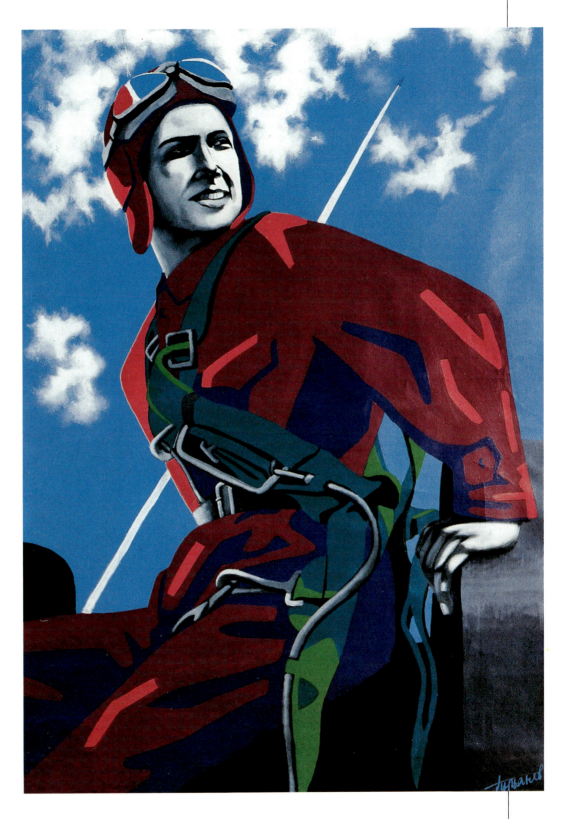

The first galleries began to appear in 1989 and provided space both for the works of art and prominent social events. All the interest of the artistic world had previously been concentrated on Western art galleries and museums; now artistic life became quite self-sufficient and acquired the inner dimensions it needed. It is remarkable that the opening of art galleries at home coincided with a recession in the West, where many art galleries curtailed their business. This recession was in fact one of the reasons why the stir around Russian art subsided. Today even the artists who have been successful abroad try to use the opportunities created by 'the art galleries boom' and display their works in Moscow. Not only that, foreign artists bring their works to be displayed in Russia, and large-scale joint projects are being realised. This testifies to the fact that following the period of 'the Russian boom', Russia has really been integrated into international art.

25. Timur Novikov, Untitled, 1992, Cloth, postcard, bijouterie, 210 x 164 cm, Courtesy: 1.0 Gallery, Moscow

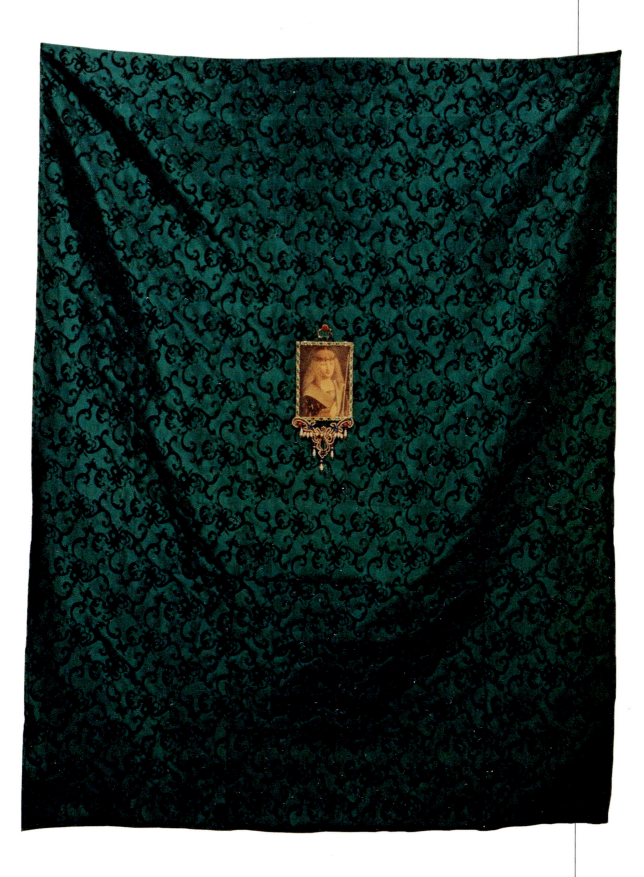

The very first art gallery opened in Moscow in 1989 was modestly called the 1st Gallery. Its founders were three young artists: Aidan, daughter of Tair Salakhov, first secretary of the USSR Artists' Union, Yevgeny Mitta and Alexander Yakut. None of them belonged to the Underground or dissident milieu. Supported by a group of new Moscow businessmen who owned a network of expensive restaurants, the artists modelled a 'truly Western' art gallery. The 1st Gallery's respectable Post-Modernist environment harmonised with the exhibitions held there. In such a setting, even the expositions of classical Moscow avant-gardists who tended to use the material found in dumps acquired a fashionable appearance that was appropriate for the beau monde. Due to the poetic touches added to this original commercial enterprise and its salon-like air, the 1st Gallery had managed to impose its cool exposition style not only on the 'middle generation' of Moscow Conceptualists, but also on the former World Champions.

26. Anatoly Zhuravlev, Untitled, 1991, An object, School globe, plastic wheels, oil, 60 x 60 x 80 cm, Author's property, Photograph: Valentin Chertok

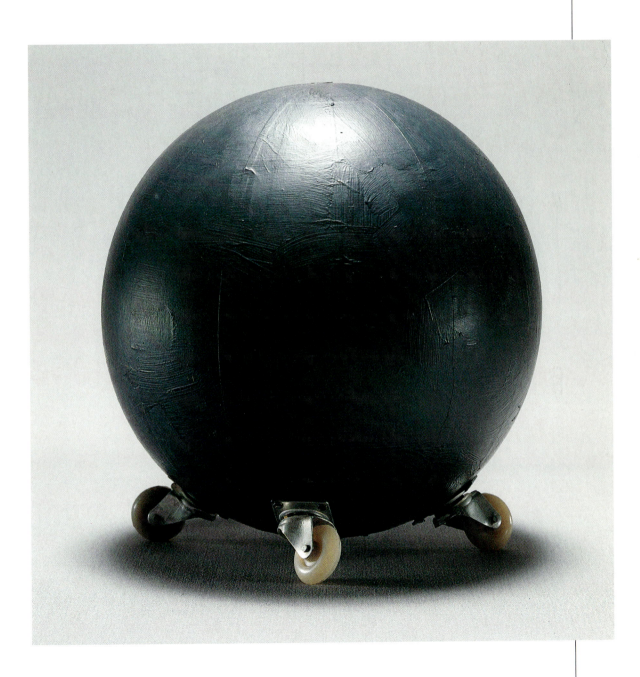

Aidan herself began with aggressive works bearing shockingly emphasised references to 'Oriental erotica'. Her later works were more monumental simulations of gorgeous 'museum' paintings and formed part of installations. A novel point in Aidan's strategy in relation to Moscow Conceptualism was the simulation of one's own body as an object and subject of art in the vein of Cindy Sherman and Jeff Koons. Gor Chokhal, who worked for the 1st Gallery, played around with his own image as a swanky young snob and regular visitor to fashionable discotheques, and the mysterious things that happened to him. In this way, by means of a programmed cosmopoliticised image, specific 'Soviet' markings were being erased.

27. Olga Chernyshova, *Rodin-Meringue*, 1989, Oil on canvas, wood, plaster, 45 x 45 x 15 cm, Contemporary art collection, Tsaritsyno Museum, Moscow, Photograph: Valentin Chertok

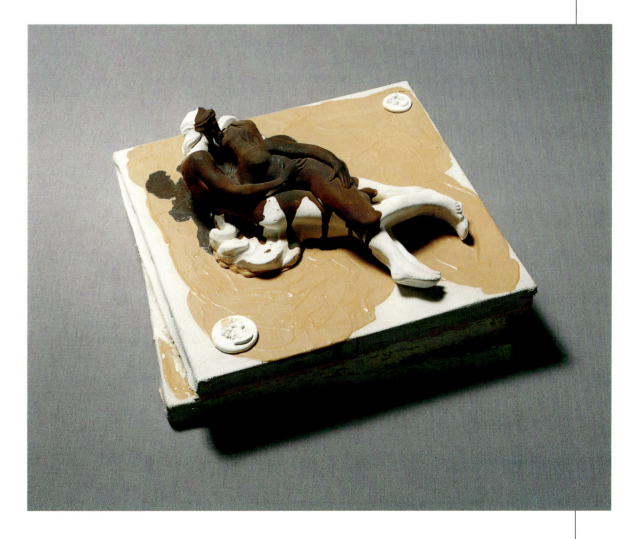

The 1st Gallery was the first to open, and it was also the first to close down — the sponsors found it too costly to pay the growing rent for the premises in the centre of Moscow. Aidan moved to her own Aidan Gallery, together with most of the artists who cooperated with the 1st Gallery. But, to all appearances, the modus of refined, slightly decadent art was still attractive, and in the summer of 1993 Alexander Yakut, Aidan's colleague, also opened his own art gallery, demonstrating a certain new conservatism and bourgeois solidity. Inna and Dmitry Topolsky and Alexander Mareev cooperate with these two galleries, using to good effect the classical image of the decadent artist — at once naive, exquisite, and sophisticated.

28. Andrei Yakhnin, *Blood Test*, 1990, Installation 'Childhood'. Detail, Canvas, silkography, 125 x 90 cm, Courtesy: 1.0 Gallery, Moscow, Photograph: Victor Lugansky

МИНЗДРАВ СССР

Код формы по ОКУД
Код учреждения по ОКПО
Медицинская документация
Форма № 224/у
Утв. Минздравом СССР 04.10.80
№ 1030

Наименование учреждения
Лаборатория

АНАЛИЗ КРОВИ № *57*

Фамилия, И., О. *Жукова Л*

Возраст

Учреждение _____ отделение *проф* палата

участок _____ медицинская карта №

	Результат	Норма			
		Единицы СИ		Единицы, подлежащие замене	
Гемоглобин М Ж	*17,0*	130,0—160,0 120,0—140,0	г/л	13,0—16,0 12,0—14,0	г %
Эритроциты М Ж		4,0—5,0 3,9—4,7	·10¹²/л	4,0—5,0 3,9—4,7	млн в 1 мм³ (мкл)
Цветовой показатель		0,85—1,05		0,85—1,05	
Среднее содержание гемоглобина в 1 эритроците		30—35	пг	30—35	пг
Ретикулоциты		2—10	‰	2—10	‰
Тромбоциты		180,0—320,0	·10⁹/л	—320,0	тыс. в 1 мм³ (мкл)
Лейкоциты	*7200*	4,0—9,0	10⁹/л	—9,0	тыс. в 1 мм³ (мкл)
Миелоциты	—	—	% ·10⁹/л	—	% в 1 мм³ (мкл)
Метамиелоциты	—	—	% ·10⁹/л	—	% в 1 мм³ (мкл)
Палочкоядерные	*5*	1—6 0,040—0,300	% ·10⁹/л	1—6 40—300	% в 1 мм³ (мкл)
Сегментоядерные	*57*	47—72 2,000—5,500	% ·10⁹/л	47—72 2000—5500	% в 1 мм³ (мкл)
Эозинофилы	*14*	0,5—5 0,020—0,300	% ·10⁹/л	0,5—5 20—300	% в 1 мм³ (мкл)
Базофилы		0—1 0—0,065	% ·10⁹/л	0—1 0—65	% в 1 мм³ (мкл)
Лимфоциты	*19*	19—37 1,200—3,000	% ·10⁹/л	19—37 1200—3000	% в 1 мм³ (мкл)
Моноциты	*9*	3—11 0,090—0,600	% ·10⁹/л	3—11 90—600	% в 1 мм³ (мкл)
Плазматические клетки	—	—	% ·10⁹/л	—	% в 1 мм³ (мкл)
Скорость (реакция) М оседания эритроцитов Ж	*4*	2—10 2—15	мм/ч		% мм/час

The intention of creating a total aestheticism clearly displayed by the 1st Gallery was also demonstrated at a large exhibition 'Aesthetic Experiments' (September 1991) held in Kuskovo, an old Russian country estate owned by Count Sheremetyevs and made into a museum in Soviet times. Its curator, Victor Misiano, appealed to the artists to change the paradigm and pass from 'the art of kitchens' to 'the art of palaces', to return to the classical understanding of Art and Beauty. Naturally, such a reactionary move could be simulation only, by way of endlessly pedalling one's adherence to the principles of 'genuine', not Modernist art, as was done, for instance, by the AES group (Tatiana Arzamasova, Lev Evzovich and Yevgeny Svyatsky). In their installation *Ornamental Anthropology* they brought the understanding of the Beautiful to one of utmost exaltation, regenerating it from the images of vulgarity and bad taste that were slavered

29. Aidan (Aidan Salakhova), Untitled, 1993, Oil on canvas, 194 x 110 cm, Author's property, Photograph: Adam Reich

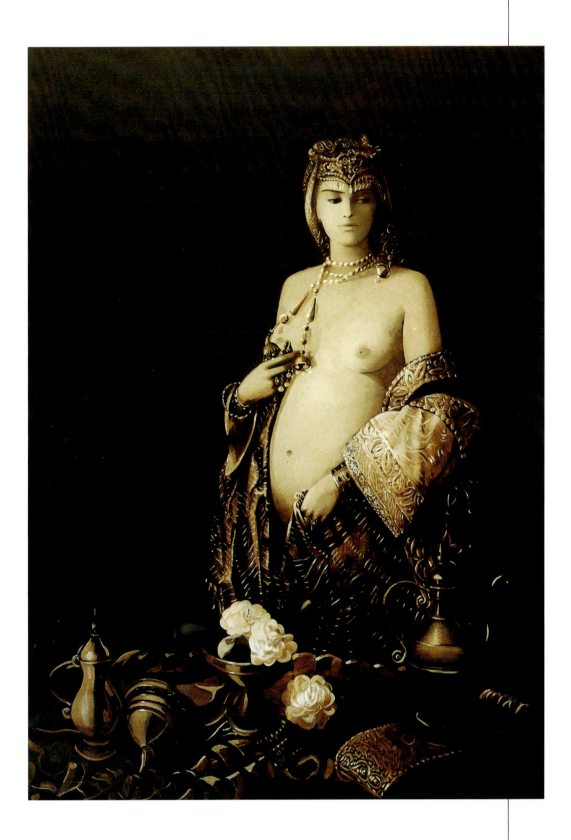

over by mass culture and mass consciousness. Valery Koshlyakov, a newcomer from Rostov, first attracted public attention at the exhibition in the Kuskovo palace and soon became the young critics' idol. He uses the ruins of packaging cardboard as a surface upon which to depict wonderful visions approbated from his own cultural memory. He is like an antiquarian in love with museum dust, craquelure and patina. In his set of landscapes on the theme of Stalinist architecture, Koshlyakov, unlike Sots Artists, who saw only the vehicles of oppression in it, is aloofly concentrated on the grandeur of the decaying colossuses of the last empire.

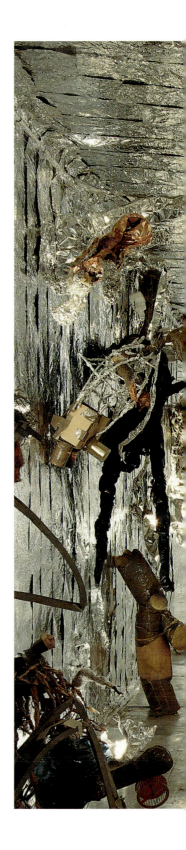

30. The ART-BLYA group, ♀ ♂, 1992, Installation, Foil, plastic, wood, metal, paper, cardboard, foam plastic, porolon, artificial flowers, Photograph: Eduard Basilia

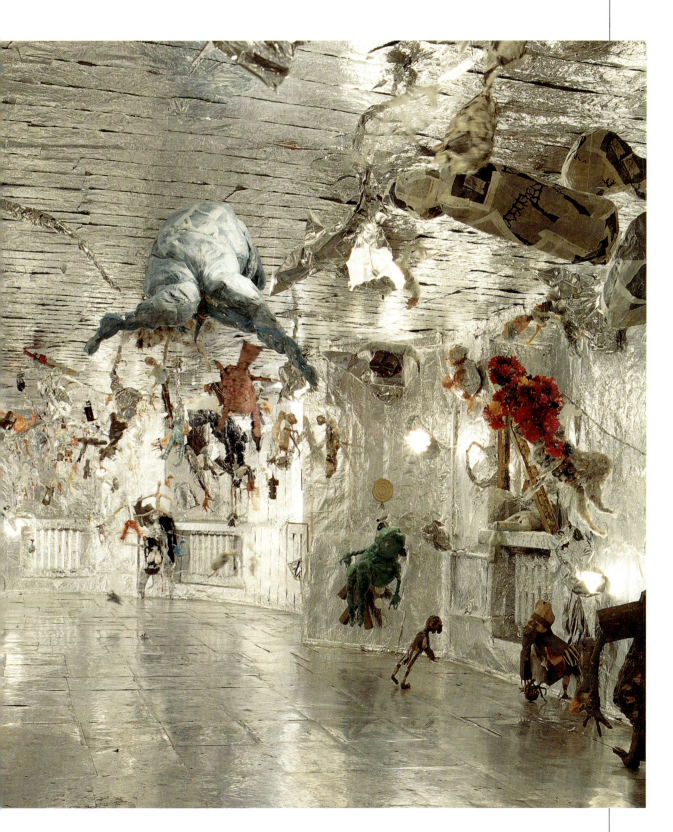

So far this discussion has mostly concerned Moscow art. Russian culture differs from the polycentric cultures of, say, Italy or Germany; it is structured in a strictly hierarchical and imperial manner. Promising artists come to Moscow to make a career. Nevertheless, there have been two competing capitals in Russia over the last three centuries: Moscow and St Petersburg (Leningrad). In the period of early Russian avant-gardism, for instance, the inner strife between the two capitals was expressed in the contrast between the rational, utilitarian Constructivism

31. The AES group (Tatiana Arzamasova, Lev Evzovich, Yevgeny Svyatsky), *Ornamental Anthropology*, 1991, Installation, Oil on canvas, cloth, paste rubies, blood transfusion tubes, 'Aesthetic Experiments' exhibition, Kuskovo palace, Grotto pavilion, Photograph: Victor Lugansky

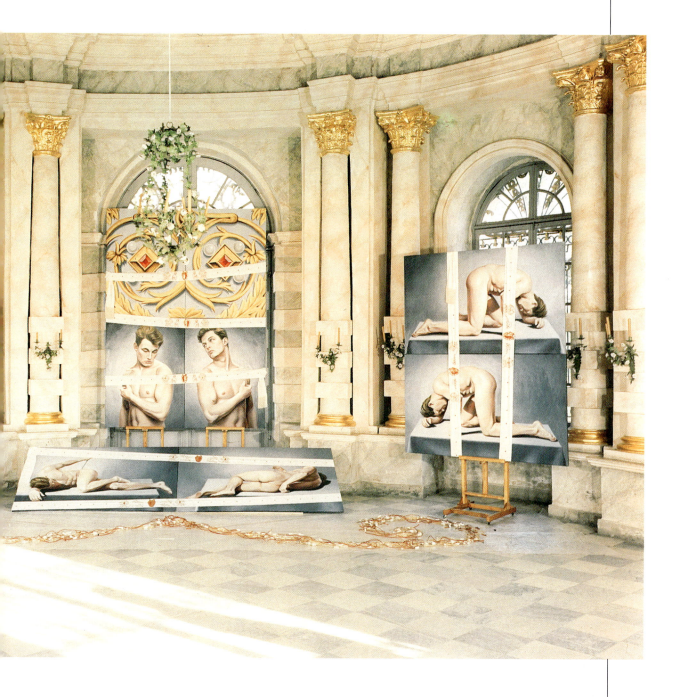

of Muscovite Alexander Rodchenko and the limitless cosmogony of Leningrader Kazimir Malevich. St Petersburg/Leningrad always had its own active tradition of independent art, which has remained practically unbroken since early avant-gardism. However, this strong tradition, by comparison with the more vague Moscow tradition, has perhaps hindered the development of experimental and radical forms of art; fuzzy, autistic forms of imitative Modernism prevailed in non-official Leningrad art.[7]

The Mitki group, which made itself known in the early 1980s, was the first to approach the problems of topical art.[8] Its members used as material for their art the brutal forms of urban folklore and their own way of life typical of Soviet lumpen-proletarians. As for the production of artefacts, their activity remained at the level of conservative representation. An even more brutal group, the necrorealists Yevgeny Yufit, Yevgeny Kondratyev, Andrei Myortvy, Sergei Serp, and others, realised itself mostly in the sphere of amateur 'parallel' films, and rarely moved into the area of pictorial art. 'Wiping the borderline

32. Dmitry Gutov, *Mozart*, 1993, Installation. Detail, Cord, 20 x 10 x 7 m, 'Trio acoustico' exhibition, Tours, France

between life and death' (from the group's manifesto), the necrorealists shocked the viewer with numerous corpses, murders and vampires and by filling their works with gloomy graveyard 'black humour' in the vein of scary children's stories.

The New Artists group, which gathered around Timur Novikov in 1982, has made its entry into the sphere of topical art. The New Artists (Sergei Bugayev [Africa], Vadim Ovchinnikov, Oleg Kotelnikov and Inal Savchenkov) are engaged in synthetic forms of effectuation in art — music, cinema, theatre, fashions, dances, performances — as the means of collective life-building and diversion.[9] They resemble East Village bohemia in their psychological make up and artistic result and combine intellectual soberness with creative urge, and a travesty-like, totally artificialised style of life, with a programmed final result.

33. Sergei Shootov and Yuri Avvakumov, *The Columbarium*, 1988, Installation at the 'Assa' artrock-parade. Detail, Mixed technique, Author's property, Photograph: Igor Palmin

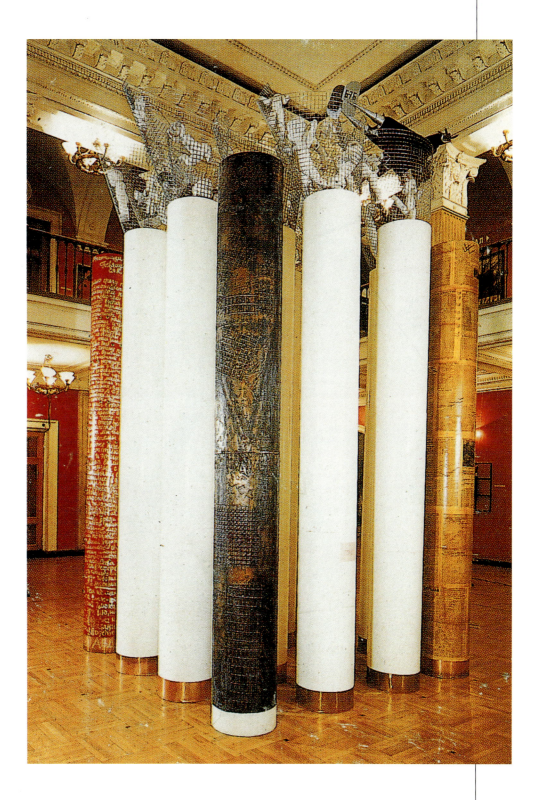

Vadim Mamyshev, a typical representative of Leningrad bohemia, presented himself with the task of recreating the image of Marilyn Monroe. In his time, Timur Novikov organised a semi-mythical 'Friends of Mayakovsky' Club, his dream being to restore the vital spirit of the revolutionary avant-garde. Latterly, the psychedelic optimism of the New Artists has turned into neoclassicism, which can be considered the most powerful trend in the art of present-day St Petersburg.[10] This transformation coincides chronologically with the Moscow simulations of a return to the classical understanding of art. But in St Petersburg, the city filled with beautiful half-decayed classical architecture, neoclassical aspirations are tinged with the decadent feeling of the impossibility of a return to the classical reality of the Beautiful. That is why the steroid *Pilots* of Georgy Guryanov, executed in the Socialist Realism manner but painted with loud aniline dyes, look so decadently elegant. Or Timur Novikov's carpets — his collages on classical themes — dissolve in their glimmering bad-taste ornamentation that is on the verge of kitsch.

34. Arsen Savadov and Yuri Senchenko, *Melancholy*, 1989, Oil on canvas, 300 x 410 cm, Private collection, New Jersey, Courtesy: M. Guelman Gallery, Moscow

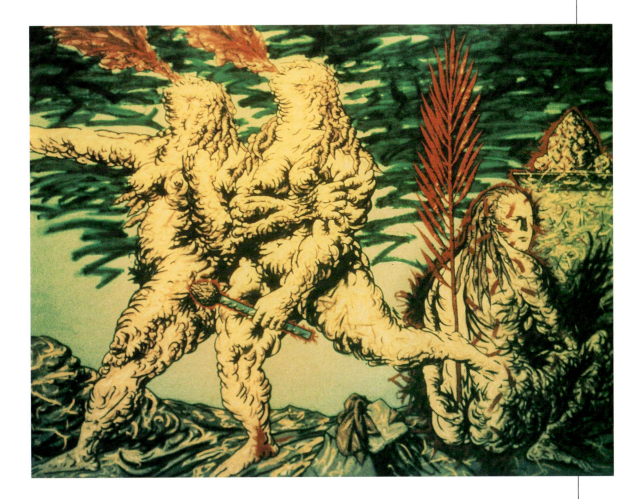

When describing 'Soviet' art we speak mostly of Moscow or St Petersburg artists. Apart from these two cities, within the borders of the Soviet empire contemporary art in more or less distinctive forms existed only in the Baltic capitals — Tallinn, Riga and Vilnius. However, because of their proclaimed regional self-sufficiency, the art of the Baltic republics should justly be viewed independently of all other artistic trends in the territory of the former Soviet Union. The Ukraine, on the other hand, retained its longstanding cultural ties with Russia after acquiring its own statehood. It remained a veritable bastion of Socialist Realism until the mid-1980s, and only a few deviations could be observed — in the salon forms of provincial Surrealism.

35. Alexander Roitburd,
The Portrait of a Lady in White,
1993, Oil on canvas, 170 x 80 cm,
Author's property, Courtesy: M.
Guelman Gallery, Moscow

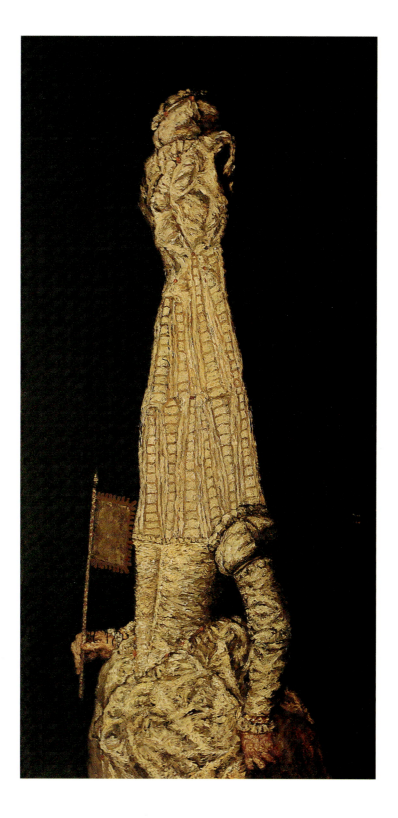

At the end of the 1980s, there appeared a group of young artists in Kiev (Arsen Savadov, Yuri Senchenko, Alexander Gnilitsky, Oleg Golosii, and others) who had managed to break intentionally the stagnant provincial narrowness of Ukrainian art.[11] On the basis of a classical education received in the Kiev Art Institute, and with a very general idea of Post-Modernism and Italian Trans-avant-gardism, they created an impressive pictorial style. *Cleopatra's Sorrow* by Arsen Savadov and Yuri Senchenko was first displayed in 1987 at the All-Union Youth Exhibition in the Manege, Moscow. The open vitality and unrestrained sweep of this big canvas, structured in compliance with the rules of academic composition, struck the viewers' imagination. The techniques of Baroque painting and Western and Eastern mythology were fused with disarming imperturbability in this gigantic picture. Excessive, even for Post-Modernism, cultural contexts ironically provoked predetermined, and ineffective, methods of interpretation in the viewers. In

36. Oleg Golosii, *A Girl with a Skipping-Rope*, 1992, Oil on canvas, 200 x 120 cm, Collection: Vladimir Ovcharenko, Courtesy: Regina Gallery, Moscow

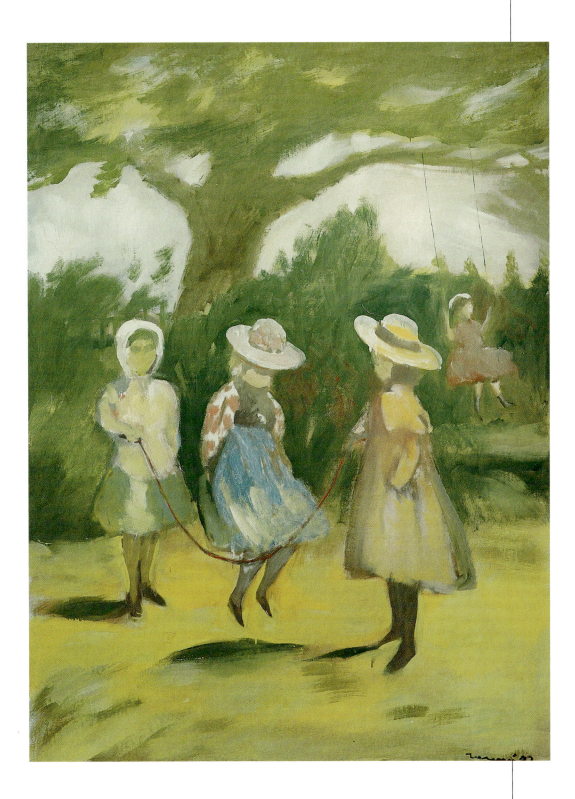

contrast to the 'cool' and intellectual Moscow tradition with its high-brow attitude to the sensuality and pageantry of art, the Ukrainian artists orientated themselves more with the 'hot' Italian Trans-avant-gardism. Achille Bonito Oliva, the father of Italian Trans-avant-gardism and author of the theory of cultural nomadism, became a cult figure among the distant descendants of south Russian steppe nomads. In actual fact, there was a complex intellectual programme behind the overwhelming force of Savadov and Senchenko's energetics, underlaid by Ch'an Buddhist exoterics with a piquant admixture of Baudrillard and Derida's deconstructivism. The artists themselves say that they prefer to meditate with Lao Tzu and Chuang Tzu. The paintings of Savadov and Senchenko may be viewed as a luxurious veil that hides the meditative mandala made up of arbitrarily chosen historico–cultural trophies — from Milton's *Paradise Lost* to a clichéd photograph of the Beatles.

37. Oleg Golosii, *Stop-Machine*, 1991, Triptych. Detail, Oil on canvas, 150 x 100 cm, Collection: Vladimir Ovcharenko, Courtesy: Regina Gallery, Moscow

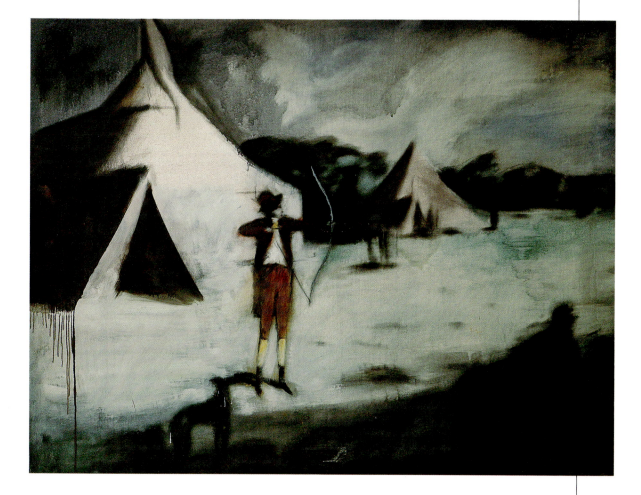

The works of Oleg Golosii, who died under tragic circumstances in 1993, were in obvious contrast to the intellectual creations of Savadov and Senchenko. Golosii represented a unique type of impulsive and romantic artist preoccupied with painting as such and producing his pieces with unbelievable vigour. Gloomy, amusing, clumsy and quaint psychedelic monsters fall in an endless stream from the recesses of the subconscious, breaking up the uniform picture of the world into a multitude of continuously piling mosaic pictures. In order to emphasise the specifics of Oleg Golosii's artistic world, Oleg Kukik, the curator of his one-man show in the Central House of Artists (autumn 1991), arranged the artist's works on carts that circled around the hall to the sound of ringing bells.

38. Oleg Migas and Anatoly Gankevich, *The Communion*, 1992, Installation. Detail, Oil on canvas, 200 x 300 cm, Property of M. Guelman Gallery, Moscow

Alexander Gnilitsky brought his specific accents into the Kievan New Wave. He also began with gigantic expressive canvases. Then, under the intellectual influence of Sergei Anufriev, a member of the Medical Hermeneutics group (which comes from the Ukrainian city of Odessa), Gnilitsky turned to the soft images of psychedelic infantilism. At the Moscow exhibition 'According to Plan' (1989, curator Vladimir Levashov), Sergei Anufriev developed a strict graphic plan of the points at which to view the pictures. In these pictures, the mythologems of different epochs drifted by like dim dreams in which culture saw its own visions.

39. Alexander Gnilitsky,
Watteau's Children, 1990,
Oil on canvas, 160 x 250 cm,
Collection: 1.0 Gallery, Moscow,
Photograph: Vladislav Yefimov

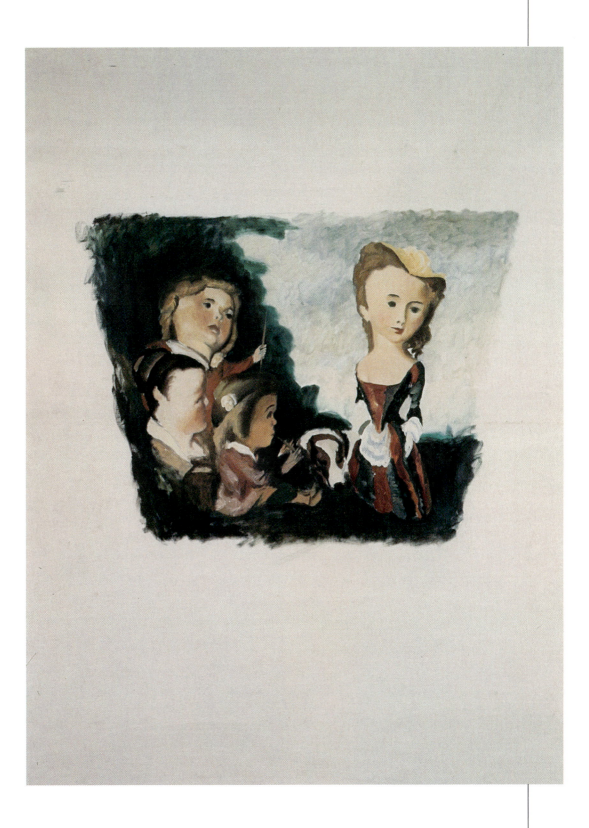

Oleg Tistol and Konstantin Reunov, who call themselves The Volitional Facet of National Post-Eclecticism, perform the role of a kind of resonator between the Baroque pressure of the Kievan Trans-avant-gardists and the intellectual coolness of Moscow Conceptualism. This group declared that it is imperative to create a synthesising national style, powerful and energetic. Paradoxically, it proposed to simulate such a style by way of condensing to the utmost the eclectics typical of the Ukrainian mentality. Some time in 1988 the Volitional Facet moved to Moscow and came under the influence of the middle generation of Conceptualists, as a result of which the element of absurd social scheming became more prominent in its works.

40. Oleg Tistol, *Shchi*, 1990,
Oil on canvas, 45 x 60 cm,
Author's property

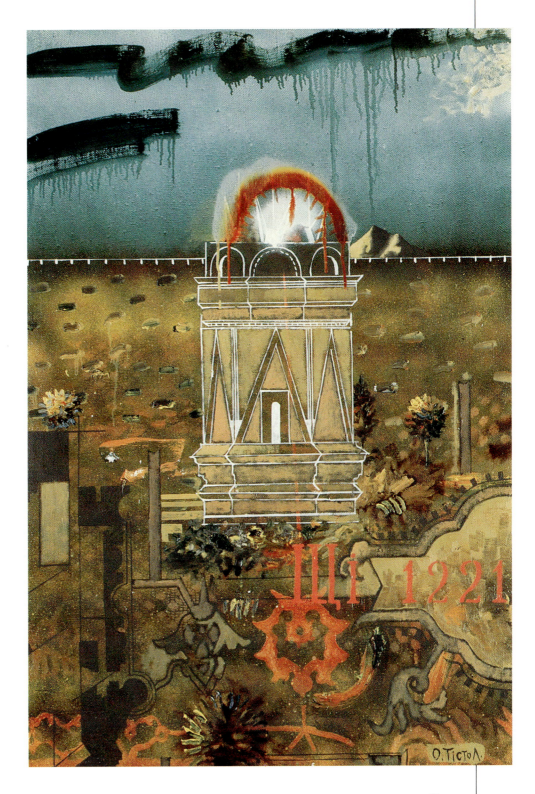

Back in 1988 Oleg Tistol produced a series of pictures called *A Project for New Ukrainian Money*, although even the bravest of minds did not dream of the Ukraine's independence at that time. Konstantin Reunov organised the action 'Humanitarian Aid' in 1991. He sent empty post packages signed by Moscow artists to the ICA in London. 'The Empty Gesture' was a loaded demonstration of a mischievous–cynical lack of awareness of political correctness.

The 'Humanitarian Aid' was sent from the gallery in Tryokhprudny Lane, whose short history represents a whole epoch in Moscow art. Early in 1991, a group of artists from southern Russia, joined by Konstantin Reunov and Oleg Tistol, gathered in a big squat in an old house that was due to be reconstructed. In the autumn of the same year they decided to arrange a small alternative gallery in the uninhabited attic. For two years,

41. Konstantin Reunov, *In Search of a Happy Ending. Only There*, 1990, Oil on canvas, 195 x 195 cm, Collection: Rinaco, Moscow

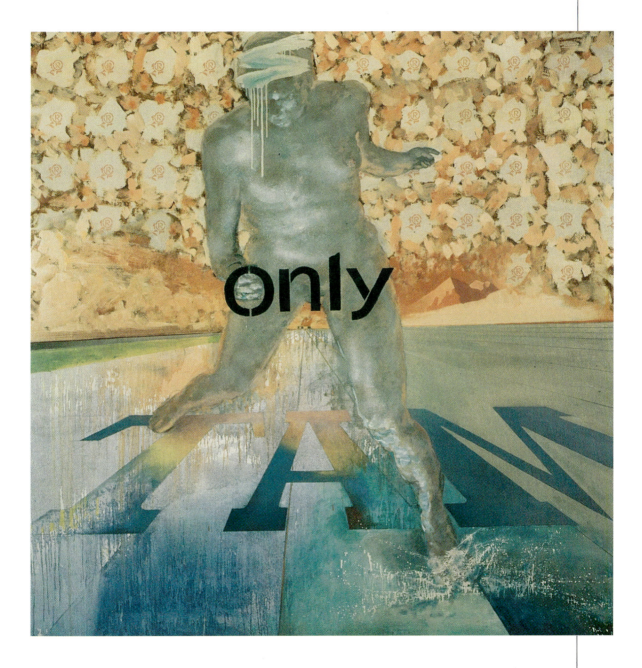

every Thursday, they held an exhibition or an action on these small premises. Simplicity was the only requirement for a display, as the gallery had no sponsors and did not engage in commercial activity. Nonetheless, the Tryokhprudny Gallery turned out to be the most radical and effective exhibition hall in Moscow.[12] Some things could only be done there: for instance, showing genuine beggars under Rembrandt reproductions ('Charity' action, Konstantin Reunov and Avdei Ter-Oganyan); or installing a homemade distiller ('Against the Monopoly' action, Mikhail Bode) and actually making samogon (home-brewed vodka) as a protest against the total pressure of the State. The discourse on alcoholism, regionally dubbed as 'Russian drunkenness', acquired special significance in the aesthetics of this gallery. Rough 'natural' drinking was contraposed to the 'unnatural' elaborate Western tradition of drug taking.

42. Valery Koshlyakov, *The Head*, from the 'Roman Portrait' series, 1992, Corrugated cardboard, tempera, 140 x 90 cm, Author's property, Courtesy: M. Guelman Gallery, Moscow

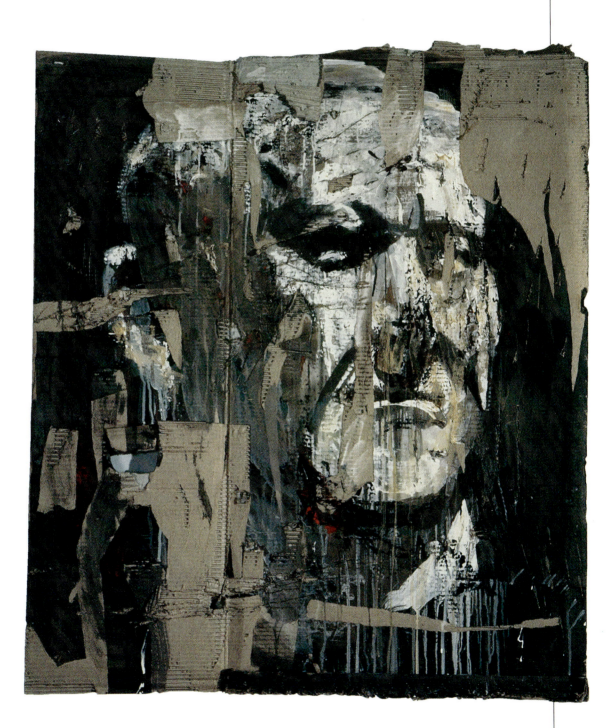

It should be said that the requirement of simplicity was based on fundamental aesthetic postulates. Behind it was opposition to the excessive intellectualism of the Conceptualists and the showy stylishness of bourgeois salons like the 1st Gallery. The Tryokhprudny Gallery practised the artificialisation of most common events in bohemian life: a sightseeing bus tour of Moscow at night in search of vodka ('All Moscow' action) or the interpretation of a private viewing as a meeting of old acquaintances in which the visitors saw only the sign 'As usual' on the wall (Victor Kasyanov). At Alexander Sigutin's one-man show another simple sign on the wall, 'Fresh Paint!', made with fresh paint, referred the visitor to the specifics of the painter's work.

43. Valery Koshlyakov, *A Patio in Alhambra*, 1991, Installation, Corrugated cardboard, tempera, 'Aesthetic experiments' exhibition, Kuskovo palace, Courtesy: M. Guelman Gallery, Moscow

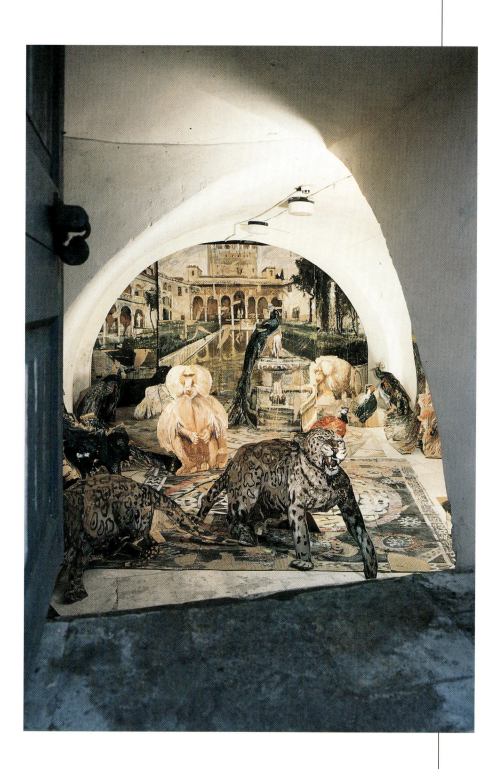

As a result of the efforts of Avdei Ter-Oganyan, the ideologist and fully-fledged dictator of the gallery, these verified unsophisticated and simple-hearted tactics were extended to the history of Modernism as well. This provincial artist studied the history of twentieth century art in the odious book *Modernism: A Critique of the Bourgeois Conceptions of Art* and learned about Duchamp and Warhol from small bleak illustrations. Now that the horizon had been greatly expanded, the thing left for him was to mark his own place as a bastard in this history and try to divest the blessed icons of Modernism of their still frightening greatness. With this purpose in mind, at the beginning of his career, Ter-Oganyan started to copy these icons — Jasper Johns's *Flag* or Warhol's portraits — in his own technique on some ruined boards. Not long ago he managed to place the *Stars and Stripes* he appropriated from Johns on the wall of the US Embassy during the action

44. Alexander Gormatyuk, Konstantin Reunov and Avdei Ter-Oganyan, *Neoacademy*, 1992, An exhibition in the gallery in Tryokhprudny Lane, Photograph: Easy Life agency

'Exchange', organised by Russians and Netherlanders (autumn 1993). At the exhibition 'Tis No Fount', a functioning urinal was taken from the toilet and placed in the exposition hall, accompanied by pictures of Roman fountains. (In slang, the phrase 'Tis no fount' [Ne fontan] indicates the poor quality of the thing being discussed, for instance, 'The beer's no fount'). Marcel Duchamp's revolutionary gesture was disintegrated with staggering simple-heartedness. 'Toward the Object' was a more principled action, with references to both world and home contexts (the above-mentioned exhibition in the Museum of Contemporary Art), where Ter-Oganyan displayed his own dead drunk body as an artefact.

45. Alexander Sigutin, Untitled, 1993, Primed canvas, 16 x 8 x 5 cm; 12.5 x 15 x 4 cm, Author's property, Courtesy: M. Guelman Gallery, Moscow

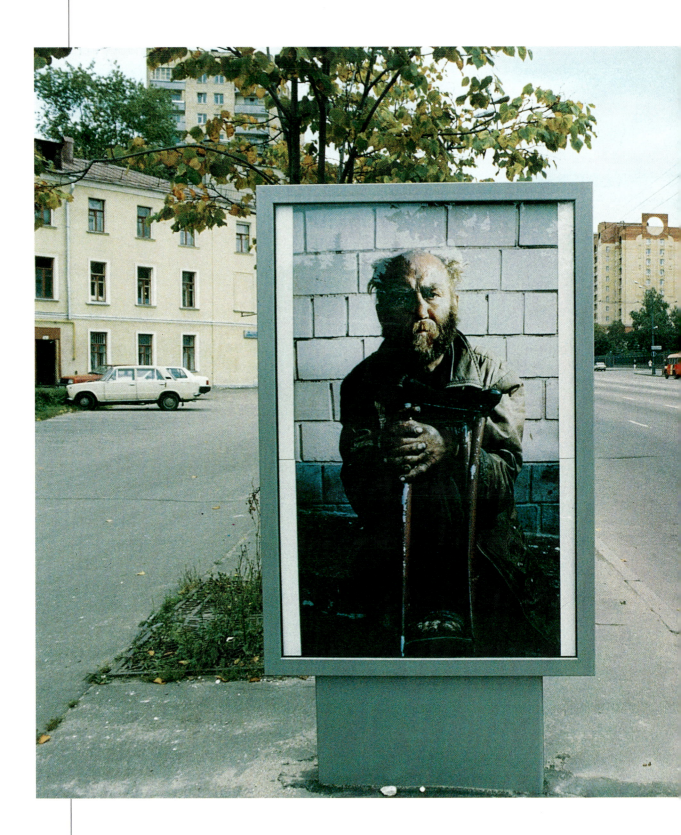

46. Aleksei Shulgin and Sergei Leontyev, Untitled, 1993, Colour photography, advertising stand, 180 x 130 cm, Photograph: Easy Life agency, Moscow

The most famous historical subject for the artists cooperating with the Tryokhprudny Gallery were reminiscences of the 1960s as seen through the prism of teenager consciousness, which replaced the appeal to the Sots Artists of the cosmos of Stalinist times. The stinging social irony of the Sots Artists gave way to a soft and unimportunate humour. It is only in taking the position of a soft infantilism that one might, like Vladimir Dubossarsky, preoccupy oneself with a collection of plaster sculpture fragments found in the studio of Nikolai Tomsky, the outstanding master of Socialist Realism. Or act like Alexander Sigutin, who was invited by Marat Gelman, the well-known Moscow gallery owner, to take part in the 'Conversation' exhibition (autumn 1933) held in conjunction with the Ministry of Defence Industry. Sigutin responded with innocent child pieces — a toy plane and a toy boat cut from primed canvas.

47. Ilya Piganov, Untitled, 1990,
Photographs, records, glass,
wood, 140 x 80 cm, Courtesy:
1.0 Gallery, Moscow,
Photograph: Victor Lugansky

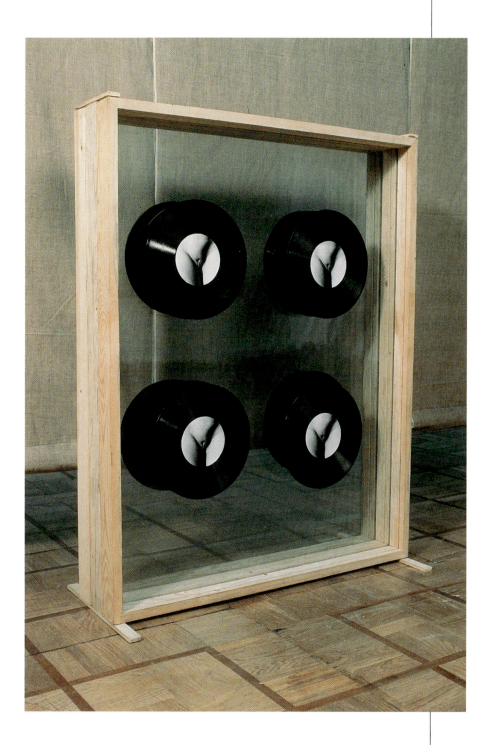

While the aesthetics of Tryokhprudny Lane emphasises its own asociality and marginality, at least two artists important to contemporary Moscow art actively work on social problems. In some other place, the desperate leftist Anatoly Osmolovsky and the apologist of capitalism Oleg Kulik would have to have been in opposition to each other. Yet, what unites them is the understanding of art as the will for power, colossal social aggressiveness, seriousness and self-confident messianism. Oleg Kulik is artistic director of Regina, the richest and most notorious gallery in Moscow.[13] Being in the service of a banking corporation, he sees his social role as that of a 'State artist'. In his opinion, the only real power of national significance in a situation where there are immature or ruined political forces is the power of money. He believes that financial corporations constitute the only real power capable of leading Russia out of its crisis, while the corporations' money is the only possibility for Russian art to liberate itself from the neocolonial rule of international art institutions and emerge upon the world scene with its own original

48. Oleg Kulik, *Drunkards in the Wood: Dedicated to Vassily Perov*, 1991, Acrylic plastic, 230 x 220 x 15 cm, Collection: Vladimir Ovcharenko, Courtesy: Regina Gallery, Moscow

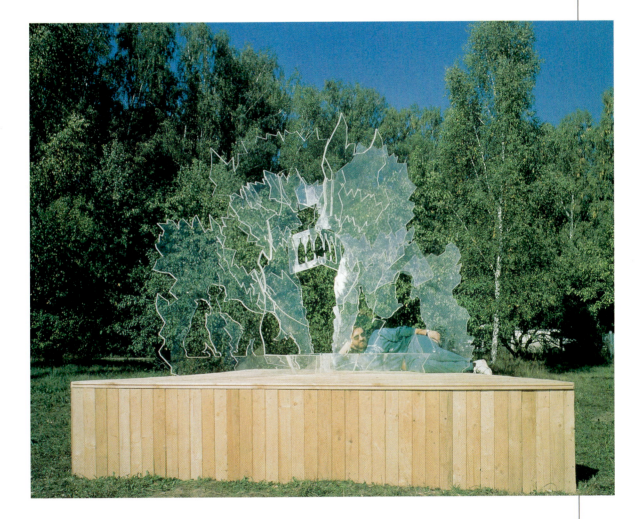

programme. Big money allows the Regina Gallery and Oleg Kulik to amuse and shock the public with more and more extravagant projects. Oleg Kulik himself acts not simply as a curator, but more as a showman who interprets an artist arbitrarily, aggressively and harshly.

He executed one such manipulation as the free curator of the one-man show of Arkady Petrov, a Sots Artist with a shade of naivety who portrayed Soviet provincial life of the 1950s–1970s. The public had to crowd into a sort of barracks Kulik made out of the artist's pictures. The first-night visitors were treated to baked suckling pigs served on plain wooden tables to the accompaniment of the KGB veterans' chorus. Kulik not only showed disrespect to this well-known artist, but also involved the public in a shady game. (It should be noted that all large-scale actions in Regina end with a staged banquet for the elite. These banquets reflect the mode of life of 'the new Russians' who, in the opinion of Pavel Pepperstein, find in the semi-criminal code of the restaurant 'the

49. Vadim Fishkin, *Three Levels*, 1992, Installation. Detail, Courtesy: Shkola Gallery, Moscow

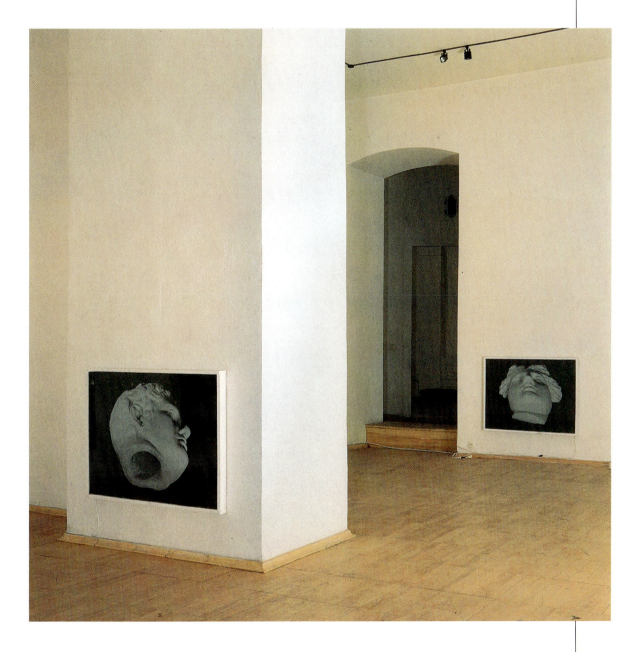

50. Anatoly Osmolovsky, *One Can Only Yell After Modernism*, 1992, Installation, Photography, collage, baguette, tape-recorder, Contemporary Art Centre, Author's property

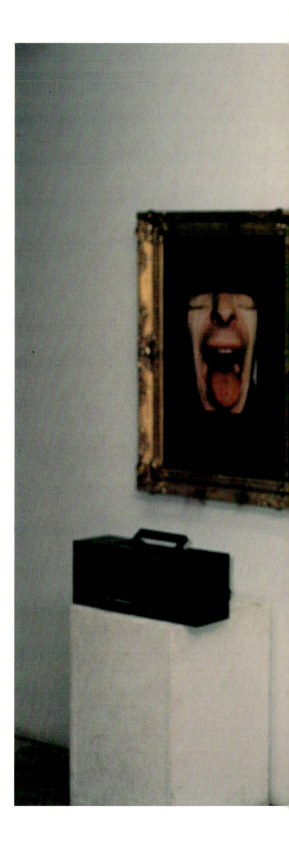

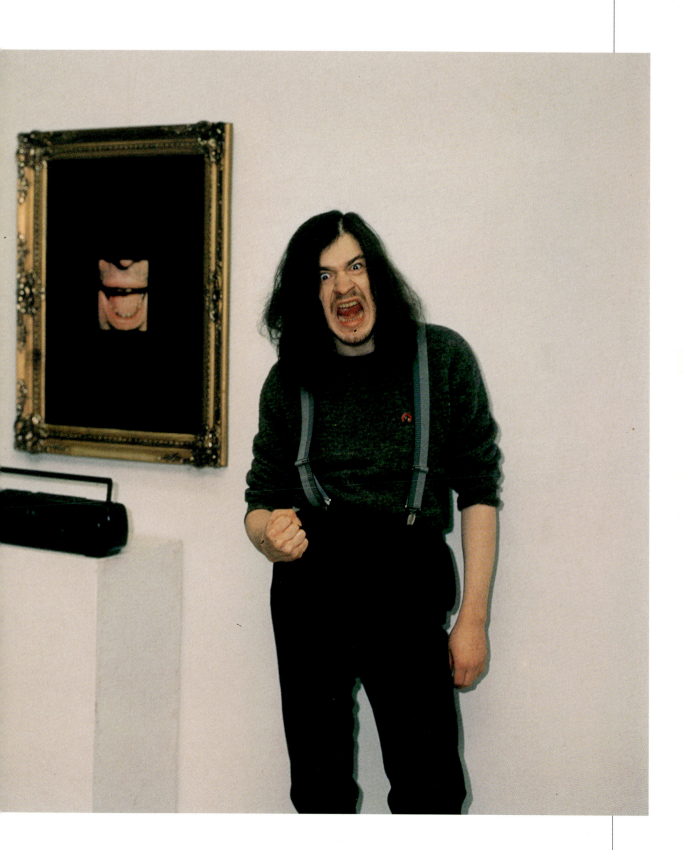

emotional element of feudal feast chambers, the world of Valhalla, of the everlasting knights' repast'.) But the most famous and scandalous action was 'Piggy gives Out Gifts' as part of the 'Animalistic Projects' festival (1992, Regina Gallery). Two professional butchers slaughtered a pig in a gallery room — which the public watched on the video monitor — and then gave out chunks of meat in black packages to the guests. The gallery was surrounded at that point by green pickets. This action turned out to be if not the most popular work of contemporary art then at least notorious for its content. Whatever the case, the poor piglet has been referred to in the press both in season and out for two years now. As an artist, Kulik is not as shockingly effective as he is in his role as showman and curator. His transparent plexiglass sculpture is called upon to express what he sees as the secret essence of power, its illusory presence in the social environment. At least the idea of 'transparency' was put forward in the guise of his being a 'State artist' — a new artistic ideology.

51. Alexander Brenner, *Good Gad!*, 1992, Cardboard, gouache, injector, Author's property, Courtesy: M. Guelman Gallery, Moscow

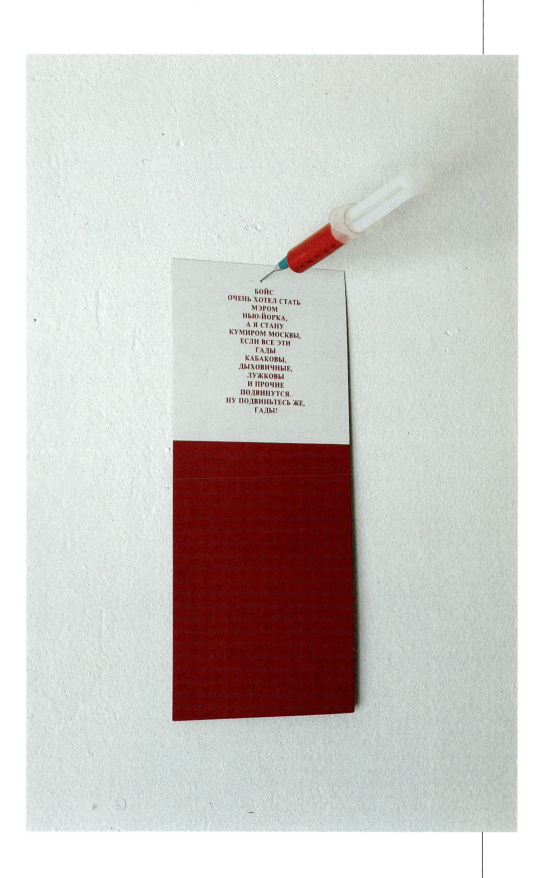

БОЙС
ОЧЕНЬ ХОТЕЛ СТАТЬ
МЭРОМ
НЬЮ-ЙОРКА,
А Я СТАНУ
КУМИРОМ МОСКВЫ,
ЕСЛИ ВСЕ ЭТИ
ГАДЫ
КАБАКОВЫ,
ДЫХОВИЧНЫЕ,
ЛУЖКОВЫ
И ПРОЧИЕ
ПОДВИНУТСЯ.
НУ ПОДВИНЬТЕСЬ ЖЕ,
ГАДЫ!

It would be natural to expect that 'the capitalist artist', the worshipper of the cult of financial corporations, should have an uncompromising opponent in the person of a lefty extremist, this role being played in Moscow by Anatoly Osmolovsky. However, the polemics between these two artists is suspiciously polite. More than that, Osmolovsky showed one of his best actions, 'Leopards Bursting into the Temple', in the Regina Gallery itself, as part of the above-mentioned 'Animalistic Projects' festival. This action featured live leopards walking in the hall near the portraits of Mayakovsky and Breton. The public, on the other hand, were in a specially made cage. To all appearances, this alliance testifies to the fact that the ideology of early capitalism propagated by Oleg Kulik is no less revolutionary than the staunch leftism thoroughly reproduced by Anatoly Osmolovsky.

52. Kirill Preobrazhensky and Aleksei Belayev, Untitled, 1992, Installation by the Permafrost group. Detail, Red lights, X-ray film, Courtesy: Shkola Gallery, Moscow

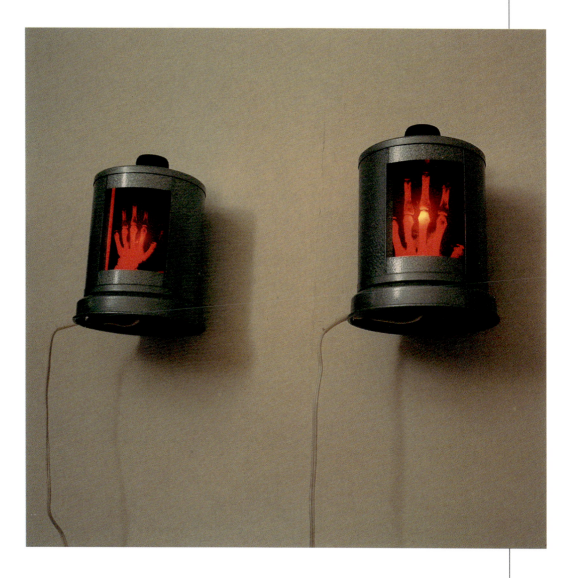

One of the first revolutionary and provocative demonstrations organised by Osmolovsky and his group called Expropriation of the Territory of Art (Russian abbreviation ETI) was the 1991 action in Red Square. Arranging their bodies in the form of the most frequently used obscene word just under 'Lenin' on the mausoleum, the ETI opened the season of revolutionary–radical art in Russia.[14] One might think that Osmolovsky was born too late, that his place is in 1968 Paris, in the thick of the events occurring there. The emergence of left extremism in the country that endured all the consequences of communist utopias, in the midst of raving 'wild capitalism' and liberal ecstasies over market models, might seem enigmatic. But the existence of capitalist romantic Oleg Kulik and left saboteur Anatoly Osmolovsky in contemporary Russian art, submerged in a sea of purely aesthetic problems, signifies the still unexhausted will of Russian culture to produce its basic product — total utopias.

53. Alexander Mareyev, *Soldiers*, 1992, Paper, black brush, gold watercolour, 85 x 30 x 30 cm, Private collection, Moscow, Courtesy: L-Gallery, Moscow

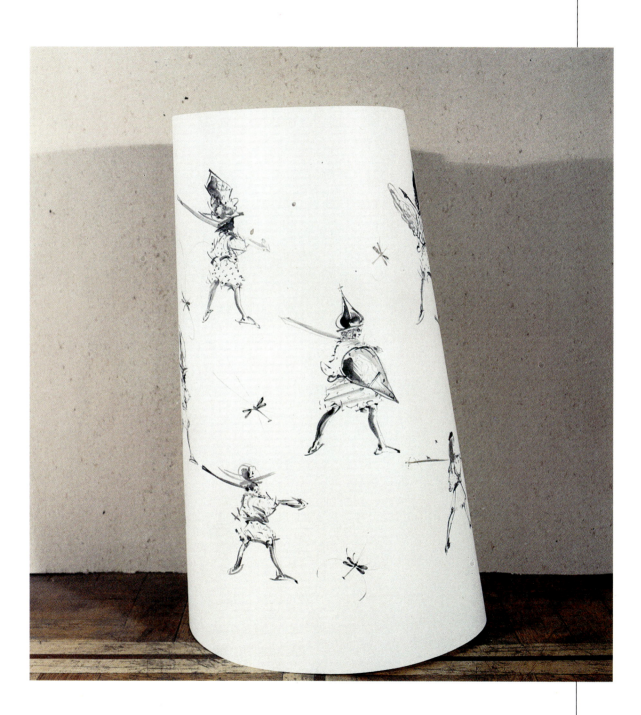

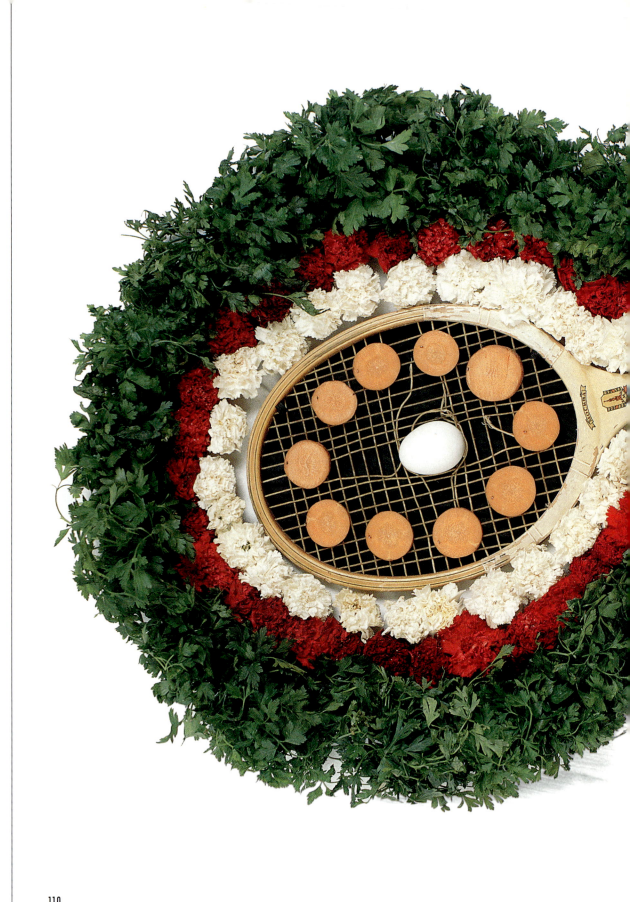

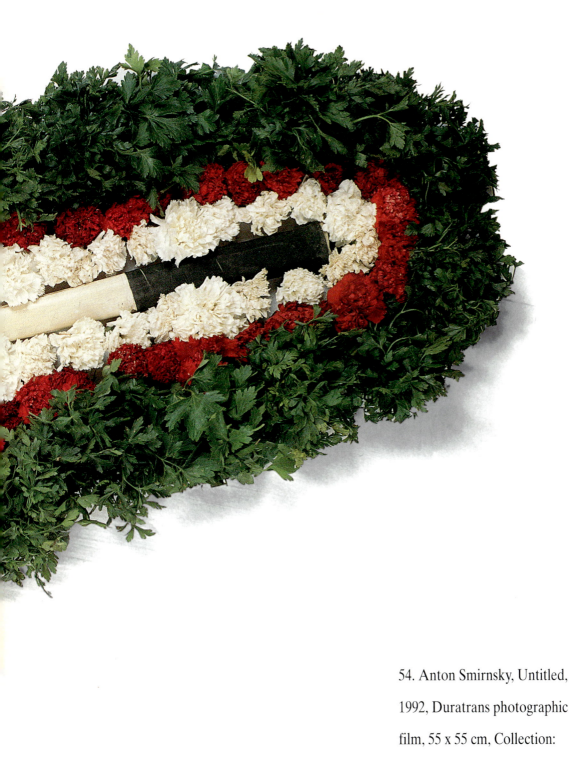

54. Anton Smirnsky, Untitled,
1992, Duratrans photographic
film, 55 x 55 cm, Collection:
1.0 Gallery, Moscow

N O T E S

1. Functioning in Moscow today are the Contemporary Art Centre (founded in 1990, first director Leonid Bazhanov; since 1992, Victor Misiano) and the Institute of Contemporary Art (established in 1991, director Josef Bacstain). As for the periodicals, a number of Soviet art journals started publishing articles on the radical forms of contemporary art in the late 1980s. The Moscow based *Iskusstvo* brought out two 'youth' issues (No 10, 1988 and No 10, 1989), while *Dekorativnoye Iskusstvo* had its regular 'Foreshortening' heading from 1989 through to 1991. From 1991 onwards, Soviet art periodicals began to close down. A single issue of the *Autograph*, Moscow, was put out in early 1993. The new *Khudozhestvenny Zhurnal* was started in September 1993. Brief information on art galleries and institutions can be found in the catalogue *International Exhibition of Eastern European Art*, 9–12 December 1993, Hamburg messe.

2. The first ART–MIF (1990) was held under the title 'An Ideal Project for the Soviet Art Market'. There were three fairs — in 1990, 1991 and 1993.

3. See, for instance, James Gambrell, 'Some Good from Politics: Soviet Art in the West', *Tvorchestvo* No 2, 1992; Vassily Rakitin, 'The Russian Wave Seems to Subside', *Tvorchestvo* No 11, 1991

4. One of the first attempts at historisation was made by Andrei Yerofeev, who compiled an issue of *Iskusstvo* (No 10, 1990) devoted to the 1970s with excerpts from Ilya Kabakov's book.

5. Konstantin Zvezdochetov, 'World Champions or the Downfall of the Last Barricade of Counterculture', *Iskusstvo* No 10, 1989; *Flash Art*, Russian edition, No 1, 1989 (Manifesto); and 'Foreshortening' in *Dekorativnoye Iskusstvo* No 6, 1990

6. Yevgenia Kikodze, 'Anton Olshwang', *Tvorchestvo* No 11, 1991

7. A review of Leningrad art in the article by Andrei Khlobystin and Alla Mitrofanova in the catalogue *Soviet Art Circa 1990*, Dusseldorf–Jerusalem–Moscow, 1990

8. 'Foreshortening' in *Dekorativnoye Iskusstvo* No 2, 1989

9. Mikhail Trofimenkov, 'New Artists', *Iskusstvo* No 10, 1988

10. *Dekorativnoye Iskusstvo* No 7/8, 1992

11. Alexander Solovyov, 'The Paths of Depicturing', *Khudozhestvenny Zhurnal* No 1, 1993

12. Yevgenia Kikodze, 'The Gallery in Tryokhprudny', *Khudozhestvenny Zhurnal* No 2, 1993

13. Regina Gallery, Chronicle, September 1990 – 9 June 1992, Moscow, 1993

14. Anatoly Osmolovsky set up a new group, Nezezuidik, in 1993 and publishes a magazine of the same name.

BIBLIOGRAPHY

Konstantin Akinsha, 'Moscow rented Leopards', *ARTnews*, summer 1992, pp 31–7

Konstantin Akinsha, 'After the Coup: Art for Art's Sake?', *ARTnews*, September 1992, pp 108–12

James Gambrell, 'Perestroika Shock', *Art in America,* Vol 77 No 2, 1986, pp 124–35

James Gambrell, 'Report from Moscow. Part I: Brave New World', *Art in America*, September 1992, pp 43–9

James Gambrell, 'Report from Moscow. Part II: The Best and the Worst of Times', *Art in America*, November 1992, pp 52–60

Boris Grois, *Zeitgenossische Kunst aus Moskau: Von der Neo-Avangarde zum Post-Stalinizmus*, Munich, 1991

Silvia Hochfeld, 'Reinventing an Art World', *ARTnews*, Vol 90 No 2, 1992, pp 89–92

Andrej Kowaljow 'Moskauer Kunst-Chronic: Die Kunst nach den Barrikaden', *Osteuropa: Zeitschrift für Gegenwartsfragen des Ostens*, No 10, 1991, pp 947–56

Andrej Kowaljow 'Moskauer Kunst-Chronic: Von der Auction Sotheby's bis zu Barrikaden', *Osteuropa: Zeitschrift für Gegenwartsfragen des Ostens*, No 1, 1993, pp 73–82

Andrej Kowaljow 'Moskauer Kunst-Chronic: Seit der Wende im Herbst 1986', *Osteuropa: Zeitschrift für Gegenwartsfragen des Ostens*, No 11, 1993, pp 1089–100

Victor Misiano, 'Ars Post Mortem', *Flash Art International Edition*, Vol 23 No 153, summer 1990, pp 130–33

Victor Misiano, 'Old Fashioned Passion', *Flash Art International Edition*, Vol 24 No 158, May/June 1991, pp 110–13

Victor Misiano, 'Far Away to Ideology', *Flash Art International Edition*, Vol 24 No 6, October 1992, pp 70–2

LIST OF ILLUSTRATIONS

1. Avdei Ter-Oganyan, *Marcel Duchamp. 'Fountain'*, from the 'Pictures for the Museum' series, 1992, Oil on canvas, 100 x 90 cm, Contemporary art collection, Tsaritsyno Museum, Moscow, Photograph: Easy Life agency

2. Oleg Kulik, *Gorby*, 1992, Armoured glass, 320 x 160 x 120 cm, Collection: European Merchant Bank, Moscow, Photograph: Vadim Zemsky

3. Konstantin Zvezdochetov, *Procession*, from the 'Perdo' series, 1987, Orgalite, alkyd enamel, 100 x 150 cm, Private collection, Germany

4. Yuri Leiderman, *The Well and the Pendulum*, 1992, Installation, Wood, paper, metal, plaster figurines, 'Animalistic Projects' festival, Regina Gallery, Moscow

5. Sergei Shootov, *Sensuous Experiments*, 1993, Video-installation. Detail, Courtesy: Shkola Gallery, Moscow

6. Aidan (Aidan Salakhova), *Golden Legend*, 1991, Installation in the 1st Gallery. Detail, Oil on canvas, papier-maché fruit, Courtesy: Aidan Gallery, Moscow

7. Dmitry and Inna Topolsky, *The Artist and the Model*, 1993, Photograph, 75 x 60 cm, Courtesy: Yakut Gallery, Moscow

8. Gor Chokhal, *Sentimental Travel*, 1990, Installation in the 1st Gallery. Detail, Courtesy: Aidan Gallery, Moscow

9. Vladislav Mamyshev, *Unhappy Love*, 1993, Painted photograph, 60 x 70 cm, State Russian Museum, St Petersburg, Photograph: Hans Yörgen Buckard

10. Arsen Savadov and Yuri Senchenko, Untitled, 1992, Oil on canvas, plastic, 350 x 400 cm, Oklahoma City Museum, USA, Courtesy: M. Guelman Gallery, Moscow

11. Oleg Tistol and Konstantin Reunov, *An Act of Artistic Opposition*, 1990, 'The Late-Century Art' Programme, The Artist's Central House, Moscow

12. Yuri Khorovsky, *Voting on the Question of Socrates: Death Penalty, 399 BC*, 1993, Installation. Detail, 10 x 1 x 1 m, Author's property, Courtesy: M. Guelman Gallery Moscow

13. Avdei Ter-Oganyan and Alexander Sigutin, *The Futurists Going to the Kuznetsky: In Commemoration of Kazimir Malevich and Aleksei Morgunov's First Public Performance*, 1992, Moscow, Photograph: Igor Mukhin

14. Alexander Sigutin, *Fresh Paint*, 1993, Art exhibition in Tryokhprudny Lane, Photograph: Igor Mukhin

15. Oleg Kulik, *Art at First Hand or the Apologia of Diffidence*, from Vladimir Ovcharenko's collection, 1992, Exposition project, Regina Gallery, Moscow, Photograph: Pavel Kiselyov

16. Anatoly Osmolovsky, *Leopards Bursting into the Temple*, 1992, Installation. Detail, 'Animalistic Projects' festival, Regina Gallery, Moscow

17. Giya Abramishvili in front of *Reagan* (1987) by the World Champions group in the studio in Furmanny Lane, Moscow, 1988

18. Konstantin Zvezdochetov, *Indices*, 1986, Oil on canvas, 200 x 150 cm, Private collection, Germany

19. Timur Novikov and Inal Savchenkov in front of Inal Savchenkov's painting. Photograph: from the cover of a special 'youth' issue of *Iskusstvo* magazine (No 10, 1988), Moscow

20. Yuri Leiderman, *The Best and Very Dubious*, 1991, Installation. Detail, Oil on canvas, cardboard, paper, crayon, 1.0 Gallery, Moscow, Author's property

21. Nikita Alekseyev, *The Gun and the Telephone*, 1987, Oil cloth, tempura, 135.5 x 267 cm, Contemporary art collection, Tsaritsyno Museum, Moscow

22. Nikolai Kozlov, *Bad Regime*, 1987, Installation, Mixed technique, 284 x 74 x 15 cm, Contemporary art collection, Tsaritsyno Museum, Moscow

23. Anton Olshwang, *At a Piece of Work*, 1991, Installation, 'In the Rooms' exhibition, Bratislavia, Aluminium, Contemporary art collection, Tsaritsyno Museum, Moscow

24. Georgy Guryanov, *The Pilot*, 1989, Canvas, acrylic, 185 x 110 cm, Paul Judelson Arts, New York

25. Timur Novikov, Untitled, 1992, Cloth, postcard, bijouterie, 210 x 164 cm, Courtesy: 1.0 Gallery, Moscow

26. Anatoly Zhuravlev, Untitled, 1991, An object, School globe, plastic wheels, oil, 60 x 60 x 80 cm, Author's property, Photograph: Valentin Chertok

27. Olga Chernyshova, *Rodin-Meringue*, 1989, Oil on canvas, wood, plaster, 45 x 45 x 15 cm, Contemporary art collection, Tsaritsyno Museum, Moscow, Photograph: Valentin Chertok

28. Andrei Yakhnin, *Blood Test*, 1990, Installation 'Childhood'. Detail, Canvas, silkography, 125 x 90 cm, Courtesy: 1.0 Gallery, Moscow, Photograph: Victor Lugansky

29. Aidan (Aidan Salakhova), Untitled, 1993, Oil on canvas, 194 x 110 cm, Author's property, Photograph: Adam Reich

30. The ART-BLYA group, ♀♂, 1992, Installation, Foil, plastic, wood, metal, paper, cardboard, foam plastic, porolon, artificial flowers, Photograph: Eduard Basilia

31. The AES group (Tatiana Arzamasova, Lev Evzovich, Yevgeny Svyatsky), *Ornamental Anthropology*, 1991, Installation, Oil on canvas, cloth, paste rubies, blood transfusion tubes, 'Aesthetic Experiments' exhibition, Kuskovo palace, Grotto pavilion, Photograph: Victor Lugansky

32. Dmitry Gutov, *Mozart*, 1993, Installation. Detail, Cord, 20 x 10 x 7 m, 'Trio acoustico' exhibition, Tours, France

33. Sergei Shootov and Yuri Avvakumov, *The Columbarium*, 1988, Installation at the 'Assa' artrock-parade. Detail, Mixed technique, Author's property, Photograph: Igor Palmin

34. Arsen Savadov and Yuri Senchenko, *Melancholy*, 1989, Oil on canvas, 300 x 410 cm, Private collection, New Jersey, Courtesy: M. Guelman Gallery, Moscow

35. Alexander Roitburd, *The Portrait of a Lady in White*, 1993, Oil on canvas, 170 x 80 cm, Author's property, Courtesy: M. Guelman Gallery, Moscow

36. Oleg Golosii, *A Girl with a Skipping-Rope*, 1992, Oil on canvas, 200 x 120 cm, Collection: Vladimir Ovcharenko, Courtesy: Regina Gallery, Moscow

37. Oleg Golosii, *Stop-Machine*, 1991, Triptych. Detail, Oil on canvas, 150 x 100 cm, Collection: Vladimir Ovcharenko, Courtesy: Regina Gallery, Moscow

38. Oleg Migas and Anatoly Gankevich, *The Communion*, 1992, Installation. Detail, Oil on canvas, 200 x 300 cm, Property of M. Guelman Gallery, Moscow

39. Alexander Gnilitsky, *Watteau's Children*, 1990, Oil on canvas, 160 x 250 cm, Collection: 1.0 Gallery, Moscow, Photograph: Vladislav Yefimov

40. Oleg Tistol, *Shchi*, 1990, Oil on canvas, 45 x 60 cm, Author's property

41. Konstantin Reunov, *In Search of a Happy Ending. Only There*, 1990, Oil on canvas, 195 x 195 cm, Collection: Rinaco, Moscow

42. Valery Koshlyakov, *The Head*, from the 'Roman Portrait' series, 1992, Corrugated cardboard, tempera, 140 x 90 cm, Author's property, Courtesy: M. Guelman Gallery, Moscow

43. Valery Koshlyakov, *A Patio in Alhambra*, 1991, Installation, Corrugated cardboard, tempera, 'Aesthetic experiments' exhibition, Kuskovo palace, Courtesy: M. Guelman Gallery, Moscow

44. Alexander Gormatyuk, Konstantin Reunov and Avdei Ter-Oganyan, *Neoacademy*, 1992, An exhibition in the gallery in Tryokhprudny Lane, Photograph: Easy Life agency

45. Alexander Sigutin, Untitled, 1993, Primed canvas, 16 x 8 x 5 cm; 12.5 x 15 x 4 cm, Author's property, Courtesy: M. Guelman Gallery, Moscow

46. Aleksei Shulgin and Sergei Leontyev, Untitled, 1993, Colour photography, advertising stand, 180 x 130 cm, Photograph: Easy Life agency, Moscow

47. Ilya Piganov, Untitled, 1990, Photographs, records, glass, wood, 140 x 80 cm, Courtesy: 1.0 Gallery, Moscow, Photograph: Victor Lugansky

48. Oleg Kulik, *Drunkards in the Wood: Dedicated to Vassily Perov*, 1991, Acrylic plastic, 230 x 220 x 15 cm, Collection: Vladimir Ovcharenko, Courtesy: Regina Gallery, Moscow

49. Vadim Fishkin, *Three Levels*, 1992, Installation. Detail, Courtesy: Shkola Gallery, Moscow

50. Anatoly Osmolovsky, *One Can Only Yell After Modernism*, 1992, Installation, Photography, collage, baguette, tape-recorder, Contemporary Art Centre, Author's property

51. Alexander Brenner, *Good Gad!*, 1992, (Text: 'Beuys wanted to be the mayor of New York, and I'll become the idol of Moscow if all those skunks Kabakovs, Dykhovichnys, Luzhkovs and the likes of them move aside. Move aside, you skunks!'), Cardboard, gouache, injector, Author's property, Courtesy: M. Guelman Gallery, Moscow

52. Kirill Preobrazhensky and Aleksei Belayev, Untitled, 1992, Installation by the Permafrost group. Detail, Red lights, X-ray film, Courtesy: Shkola Gallery, Moscow

53. Alexander Mareyev, *Soldiers*, 1992, Paper, black brush, gold watercolour, 85 x 30 x 30 cm, Private collection, Moscow, Courtesy: L-Gallery, Moscow

54. Anton Smirnsky, Untitled, 1992, Duratrans photographic film, 55 x 55 cm, Collection: 1.0 Gallery, Moscow